ILLUSTRATED ROSARY

The Joyful Mysteries

Additional Titles

Coming Soon in 2018:

Illustrated Rosary: The Luminous Mysteries

Illustrated Rosary: The Sorrowful Mysteries

Illustrated Rosary: The Glorious Mysteries

The Complete Illustrated Rosary

ILLUSTRATED ROSARY

The Joyful Mysteries

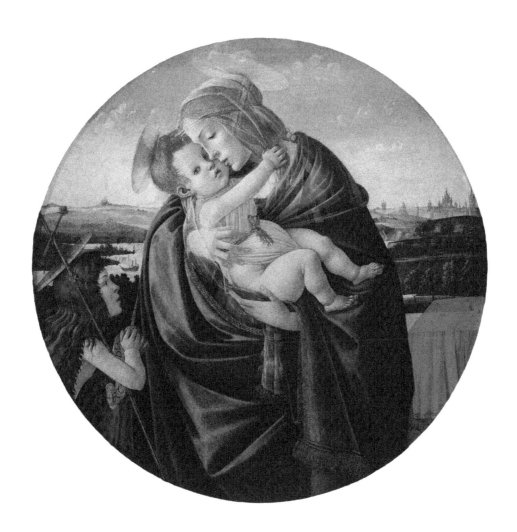

KARINA TABONE

ILLUSTRATED
PRAYER

For my family. ~ KT

Hardcover ISBN: 978-1-947986-00-8

Cover art: *Virgin and Child with Saint John the Baptist*, by Sandro Botticelli, c. 1490. The Clark Art Institute, Williamstown, Massachusetts, United States.

All prayers in this text are taken from traditional, Catholic sources.

Scripture texts in this work are taken from the Douay-Rheims 1899 American Edition Version by the John Murphy Company. Imprimatur for this bible version was given by James Cardinal Gibbons, Archbishop of Baltimore, September 1, 1899.

All artworks used in this work are faithful reproductions of two-dimensional public domain works of art which are in the public domain in its country of origin and other countries and areas where the copyright term is the author's life plus 75 years or less.

Table of Contents

Introduction

his book is a labor of love.

I first started making this book when I wanted to find a way to share the Rosary with my children when they were very young. After all, the Rosary has been there for me in some of the most challenging moments of my life, and I wanted them to be able to rely on it when challenges came their way.

The problem? It is very hard to pray the Rosary with young children.

One day during perpetual adoration, while I was juggling my two young children and trying to pray a Rosary on my fingers, a thought flitted across my mind. What if there was a book that went through each individual prayer of the Rosary, one by one, with the text of the prayer clearly printed? What if each prayer was beautifully illustrated with classic, religious artwork depicting each mystery? What if this book was designed in such a way that everyone – both children and adults – could use this book to devoutly pray the Rosary?

The more I thought about it, the more I liked the idea. After all, my children will sit down and listen to me read stories, as long as the pictures engage them. What better way to teach them to love the Rosary, our Blessed Mother, and our Lord Jesus Christ than by immersing them into the pivotal scenes of Christ's life through pictures?

And what better way to focus my own mind on the mysteries of the Rosary! After all, how many things cross my mind and distract me while I pray the Rosary? Sometimes, even the weight of the beads slipping through my fingers isn't enough to keep my tired brain from wandering away from Christ and toward to-do lists. Having that visual anchor of Christ in front of me while I prayed would be a literal Godsend.

And so I dusted off my fifteen-year-old computer that was loaded with graphic design software. I looked everywhere I could to find high-quality, classic, religious art – timeless images that I, as an adult, could look at over and over again and still see something new. I designed an interior that resembled my wedding album, with the art inset into a beautiful background of black and white sketches detailing each religious artwork.

And I created this book.

By itself, the Rosary is a powerful prayer. Speaking personally, the Rosary has helped carry me through many times, including some of my darkest moments of struggle and doubt. And I am not alone; countless others, saints and sinners alike, have used the Rosary to love Jesus, deepen their faith, and strengthen their resolve to pick up their cross and follow Christ, no matter what the cost. Venerable Fulton Sheen once summed up the Rosary by saying, "The Rosary is the book of the blind, where souls see and there enact the greatest drama of love the world has ever known; it is the book of the simple, which initiates them into mysteries and knowledge more satisfying than the education of other men; it is the book of the aged, whose eyes close upon the shadow of this world, and open on the substance of the next. The power of the Rosary is beyond description."

It is no surprise that the mysteries of the Rosary have been a special focus for artists for centuries. These artists, from unknown icon makers to the Renaissance greats and beyond, have been inspired by the life of Jesus to create some of the greatest and lasting masterpieces of all time, depicting our Lord Jesus Christ and Blessed Mother. These art pieces can touch us in ways that help us experience the message of the gospel in an even deeper way. As St. John Damascene once said, "The beauty of the images moves me to contemplation, as a meadow delights the eyes and subtly infuses the soul with the glory of God."

This book leads you prayer by prayer through the Joyful Mysteries of the Rosary, with each prayer beautifully illustrated with Christian artwork that comes from our rich heritage of faith. Every picture depicts the mystery that is being prayed so that it makes it easier for anyone to focus and reflect on the mystery, no matter how busy, tired, distracted, or wiggly we can sometimes all be.

The Rosary is one of the most powerful prayers that we can pray. Every repeated prayer invites us personally to draw closer to Jesus and to unite our trials and tribulations with His own as we contemplate His life. It is my sincere hope that this book helps you pray the Joyful Mysteries with great devotion and draws you into a closer relationship with Christ.

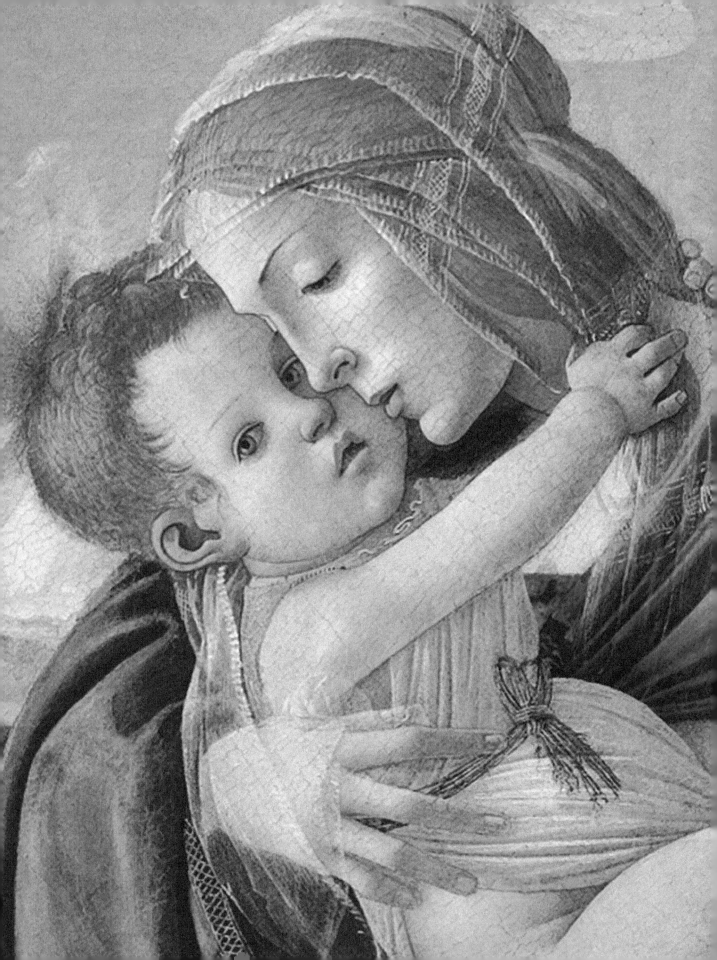

ILLUSTRATED ROSARY

The Joyful Mysteries

Sign of the Cross

In the name of the Father,
and of the Son,
and of the Holy Spirit.

Amen.

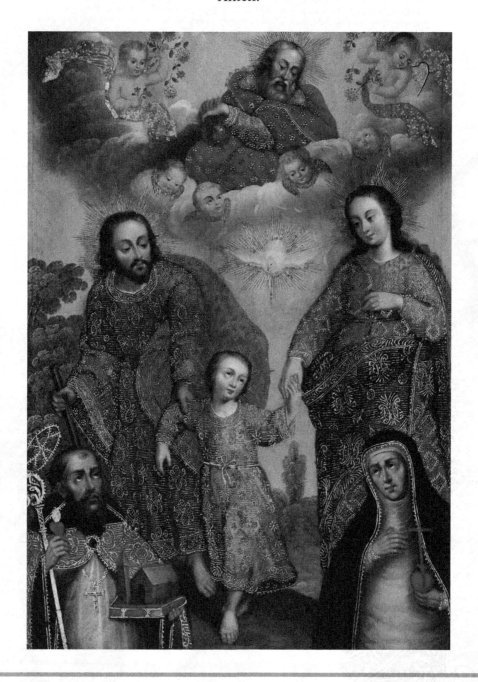

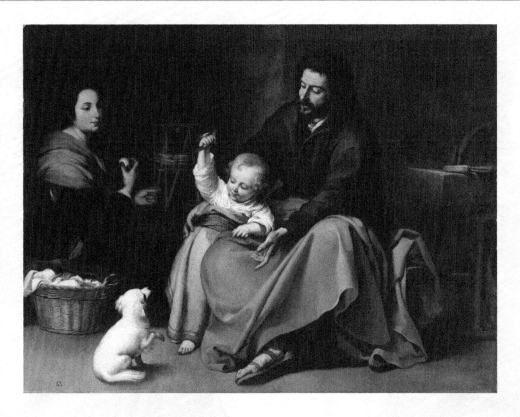

The Apostles' Creed

I believe in God, the Father almighty,
Creator of heaven and earth,
and in Jesus Christ, His only Son, our Lord,
who was conceived by the Holy Spirit,
born of the Virgin Mary,
suffered under Pontius Pilate,
was crucified, died, and was buried;
He descended into hell;
on the third day He rose again from the dead;
He ascended into heaven,
and is seated at the right hand of God the Father almighty;
from there He will come to judge the living and the dead.

I believe in the Holy Spirit, the holy catholic Church,
the communion of saints, the forgiveness of sins,
the resurrection of the body, and life everlasting.

Amen.

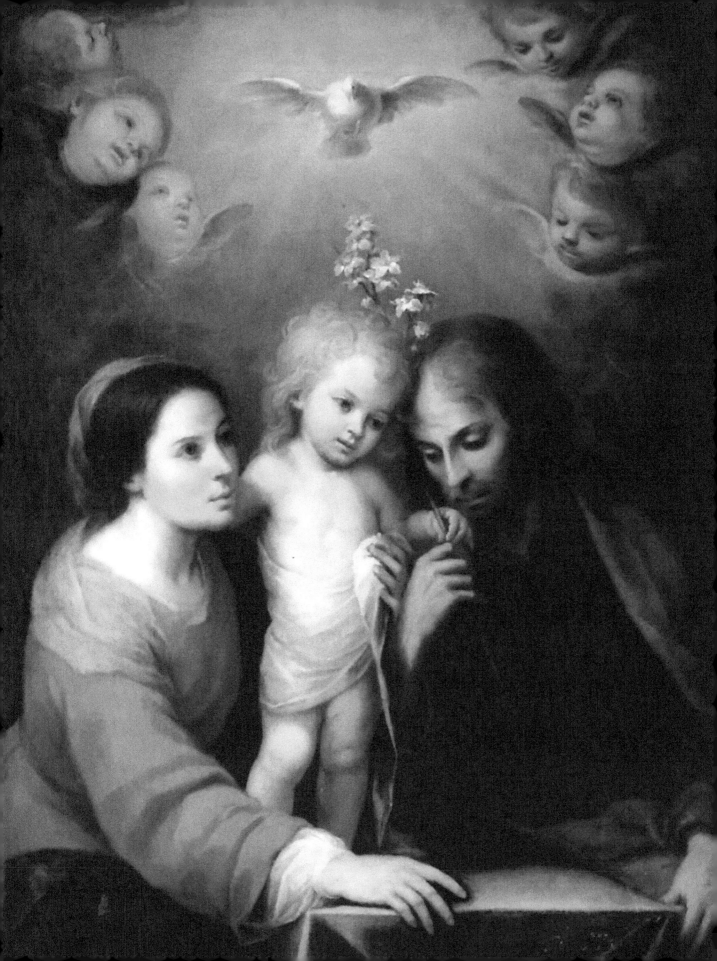

Our Father

Our Father, who art in heaven;
hallowed be Thy name;
Thy kingdom come;
Thy will be done on earth as it is in heaven.
Give us this day our daily bread;
and forgive us our trespasses
as we forgive those who trespass against us,
and lead us not into temptation;
but deliver us from evil.

Amen.

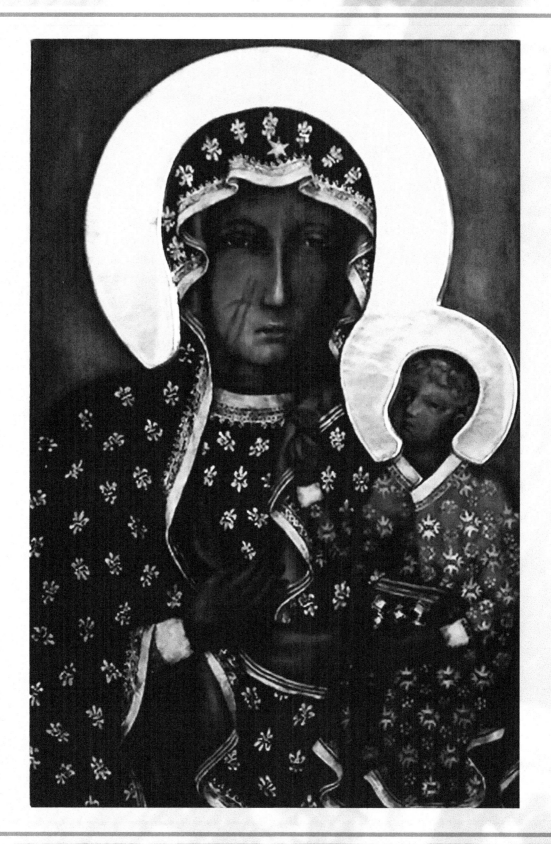

Hail Mary

Hail Mary, full of grace,
the Lord is with thee;
blessed are thou among women,
and blessed is the fruit of thy womb, Jesus.
Holy Mary, Mother of God,
pray for us sinners,
now and at the hour of our death.

Amen.

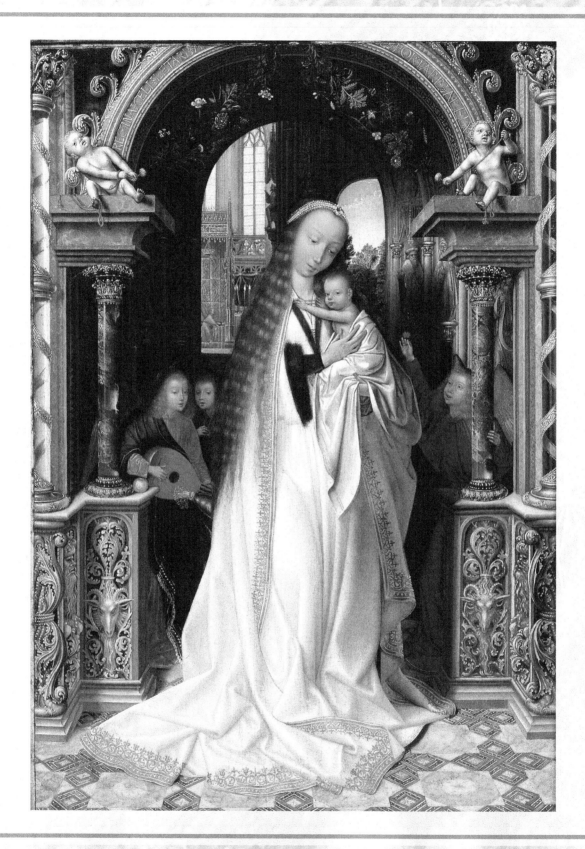

Hail Mary

Hail Mary, full of grace,
the Lord is with thee;
blessed are thou among women,
and blessed is the fruit of thy womb, Jesus.
Holy Mary, Mother of God,
pray for us sinners,
now and at the hour of our death.

Amen.

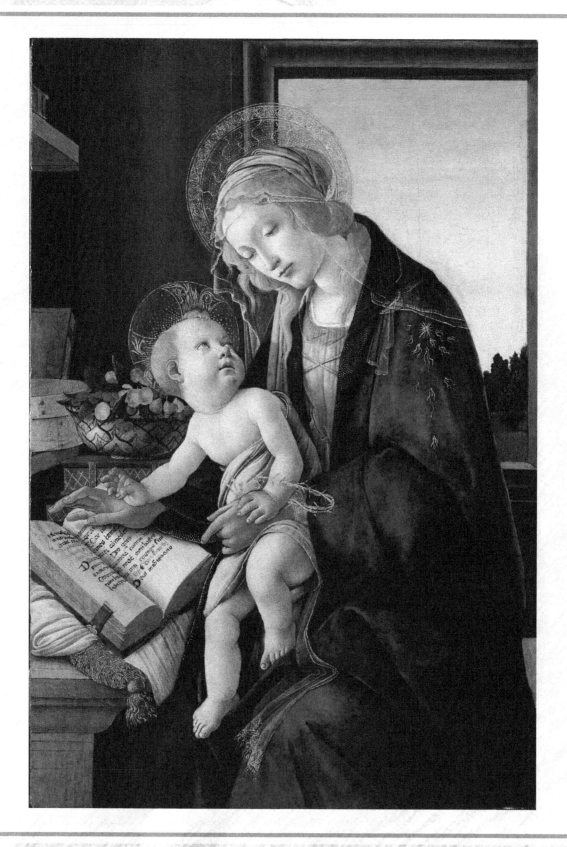

Hail Mary

Hail Mary, full of grace,
the Lord is with thee;
blessed are thou among women,
and blessed is the fruit of thy womb, Jesus.
Holy Mary, Mother of God,
pray for us sinners,
now and at the hour of our death.

Amen.

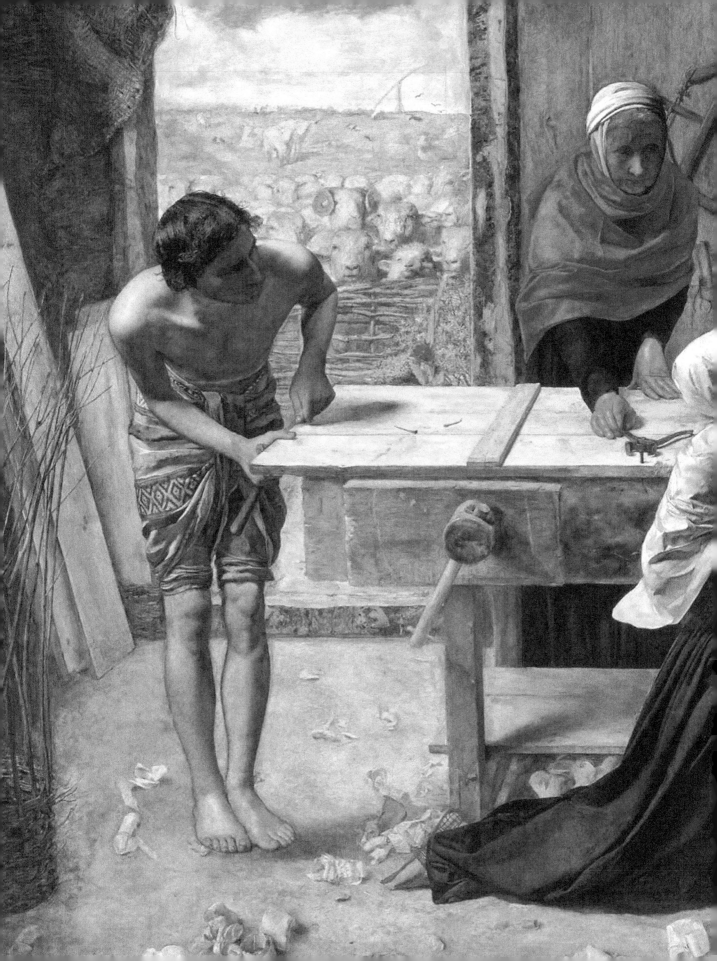

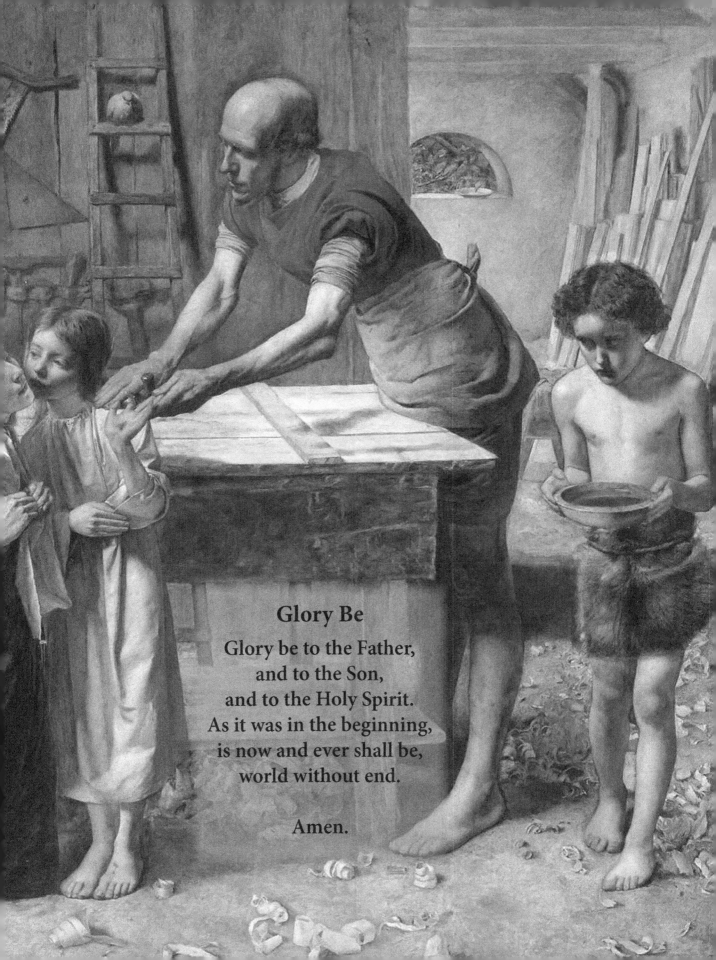

Glory Be

Glory be to the Father,
and to the Son,
and to the Holy Spirit.
As it was in the beginning,
is now and ever shall be,
world without end.

Amen.

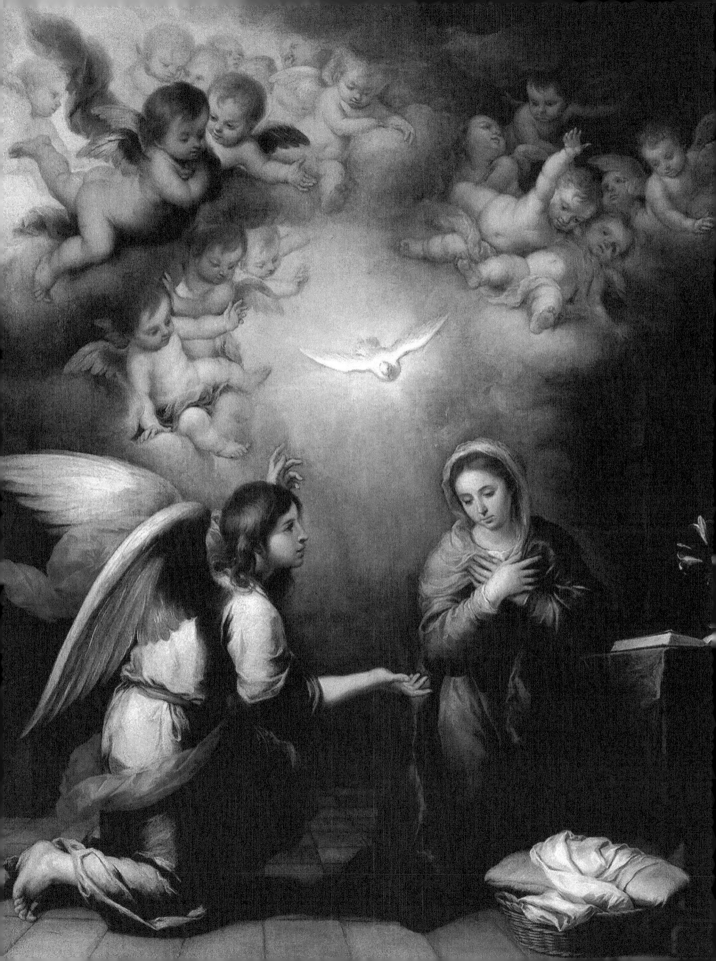

THE FIRST JOYFUL MYSTERY

The Annunciation

Luke 1:26-38

In the sixth month, the angel Gabriel was sent from God into a city of Galilee, called Nazareth, to a virgin espoused to a man whose name was Joseph, of the house of David; and the virgin's name was Mary. And the angel being come in, said unto her: Hail, full of grace, the Lord is with thee: blessed art thou among women.

Who having heard, was troubled at his saying, and thought with herself what manner of salutation this should be.

And the angel said to her: Fear not, Mary, for thou hast found grace with God. Behold thou shalt conceive in thy womb, and shalt bring forth a son; and thou shalt call his name Jesus. He shall be great, and shall be called the Son of the most High; and the Lord God shall give unto him the throne of David his father; and he shall reign in the house of Jacob for ever. And of his kingdom there shall be no end.

And Mary said to the angel: How shall this be done, because I know not man?

And the angel answering, said to her: The Holy Ghost shall come upon thee, and the power of the most High shall overshadow thee. And therefore also the Holy which shall be born of thee shall be called the Son of God. And behold thy cousin Elizabeth, she also hath conceived a son in her old age; and this is the sixth month with her that is called barren: because no word shall be impossible with God.

And Mary said: Behold the handmaid of the Lord; be it done to me according to thy word.

And the angel departed from her.

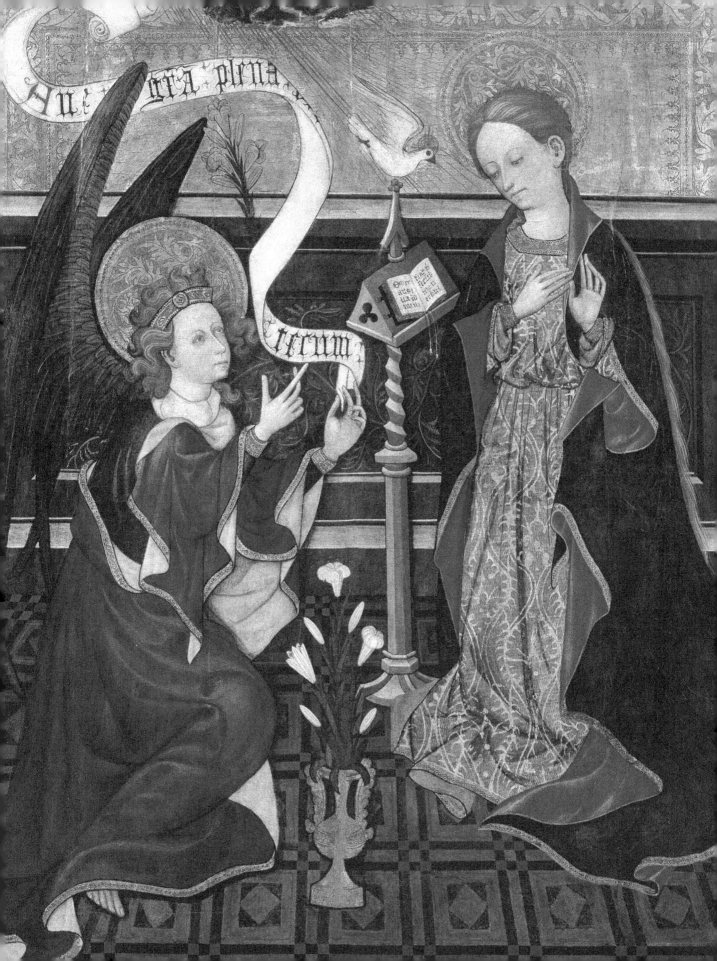

Our Father

Our Father, who art in heaven;
hallowed be Thy name;
Thy kingdom come;
Thy will be done on earth as it is in heaven.
Give us this day our daily bread;
and forgive us our trespasses
as we forgive those who trespass against us,
and lead us not into temptation;
but deliver us from evil.

Amen.

Hail Mary

Hail Mary, full of grace,
the Lord is with thee;
blessed are thou among women,
and blessed is the fruit of thy womb, Jesus.
Holy Mary, Mother of God,
pray for us sinners,
now and at the hour of our death.

Amen.

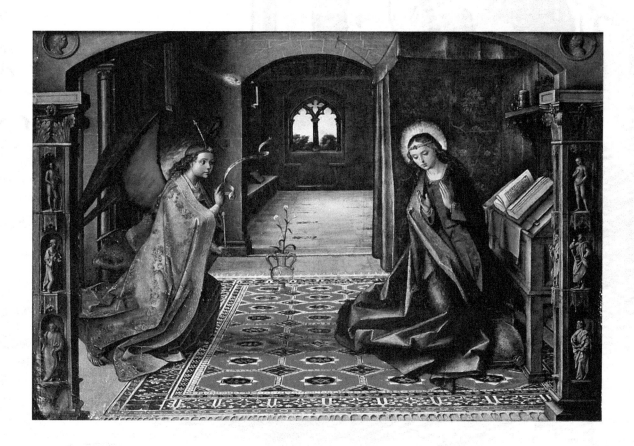

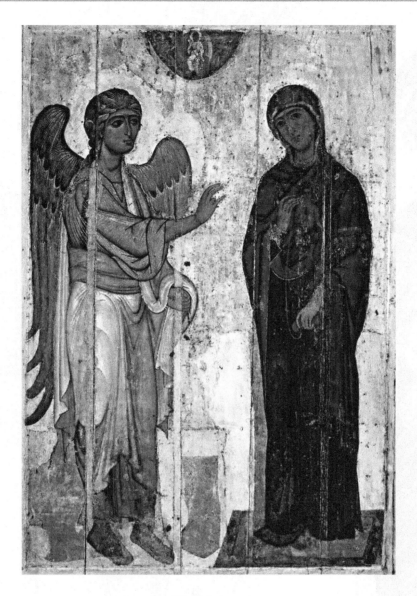

Hail Mary

Hail Mary, full of grace,
the Lord is with thee;
blessed are thou among women,
and blessed is the fruit of thy womb, Jesus.
Holy Mary, Mother of God,
pray for us sinners,
now and at the hour of our death.

Amen.

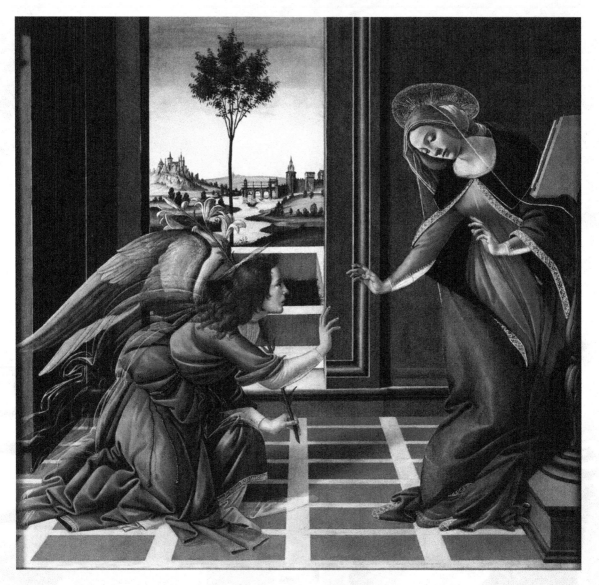

Hail Mary

Hail Mary, full of grace,
the Lord is with thee;
blessed are thou among women,
and blessed is the fruit of thy womb, Jesus.
Holy Mary, Mother of God,
pray for us sinners,
now and at the hour of our death.

Amen.

Hail Mary

Hail Mary, full of grace,
the Lord is with thee;
blessed are thou among women,
and blessed is the fruit of thy womb, Jesus.
Holy Mary, Mother of God,
pray for us sinners,
now and at the hour of our death.

Amen.

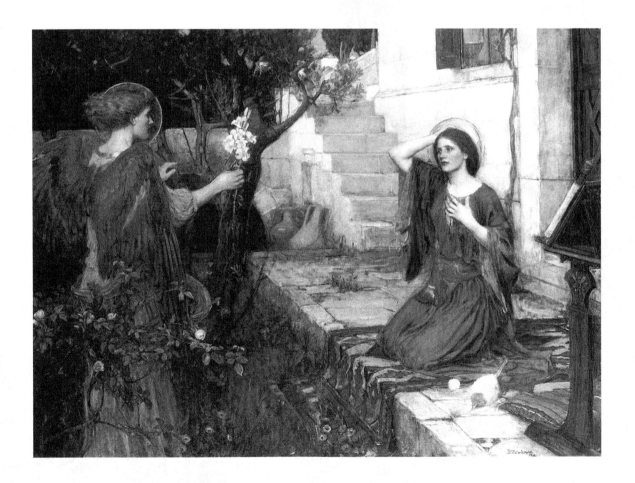

Hail Mary

Hail Mary, full of grace,
the Lord is with thee;
blessed are thou among women,
and blessed is the fruit of thy womb, Jesus.
Holy Mary, Mother of God,
pray for us sinners,
now and at the hour of our death.

Amen.

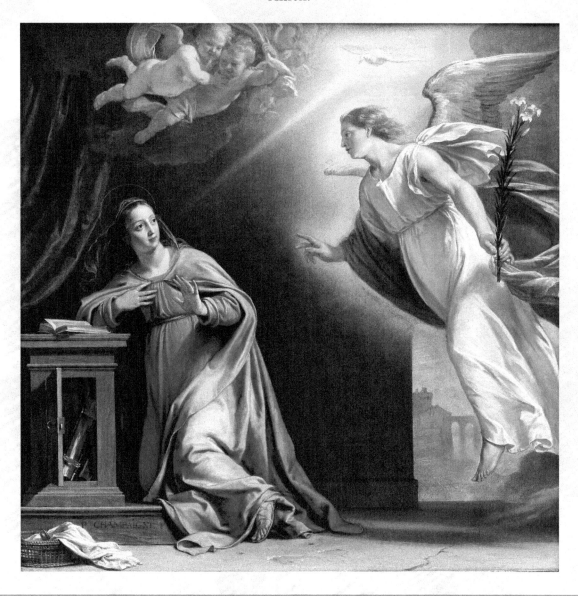

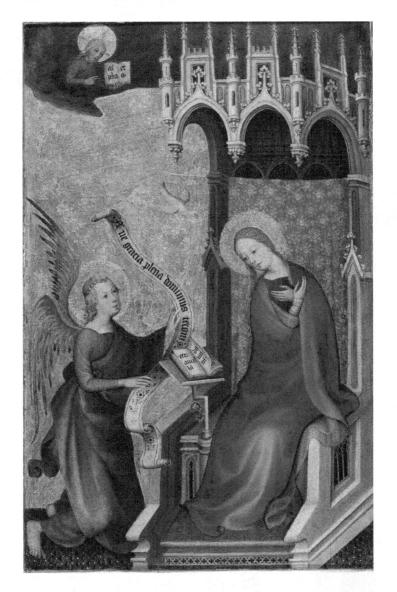

Hail Mary

Hail Mary, full of grace,
the Lord is with thee;
blessed are thou among women,
and blessed is the fruit of thy womb, Jesus.
Holy Mary, Mother of God,
pray for us sinners,
now and at the hour of our death.

Amen.

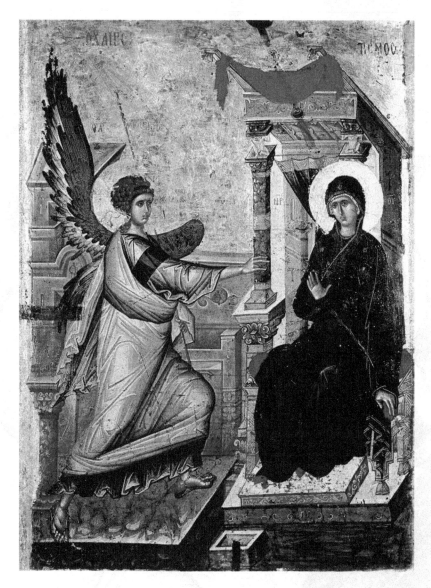

Hail Mary

Hail Mary, full of grace,
the Lord is with thee;
blessed are thou among women,
and blessed is the fruit of thy womb, Jesus.
Holy Mary, Mother of God,
pray for us sinners,
now and at the hour of our death.

Amen.

Hail Mary

Hail Mary, full of grace,
the Lord is with thee;
blessed are thou among women,
and blessed is the fruit of thy womb, Jesus.
Holy Mary, Mother of God,
pray for us sinners,
now and at the hour of our death.

Amen.

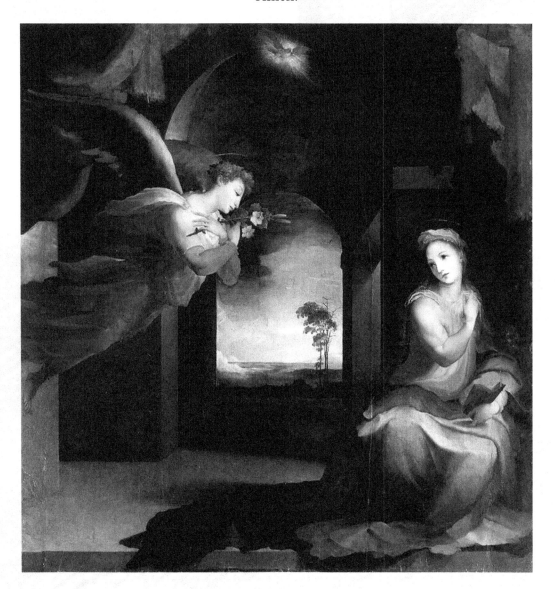

Hail Mary

Hail Mary, full of grace,
the Lord is with thee;
blessed are thou among women,
and blessed is the fruit of thy womb, Jesus.
Holy Mary, Mother of God,
pray for us sinners,
now and at the hour of our death.

Amen.

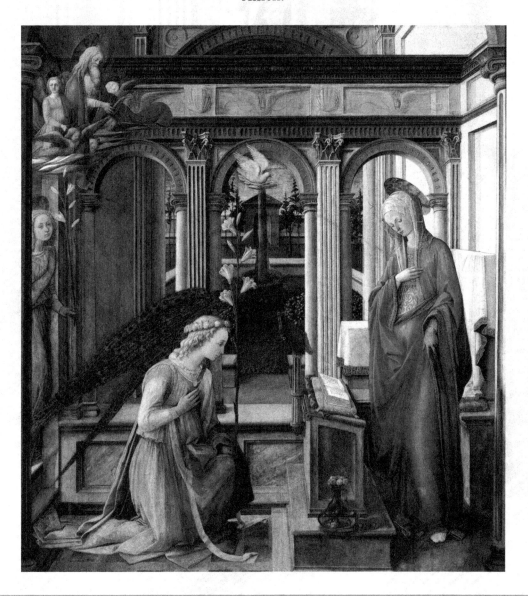

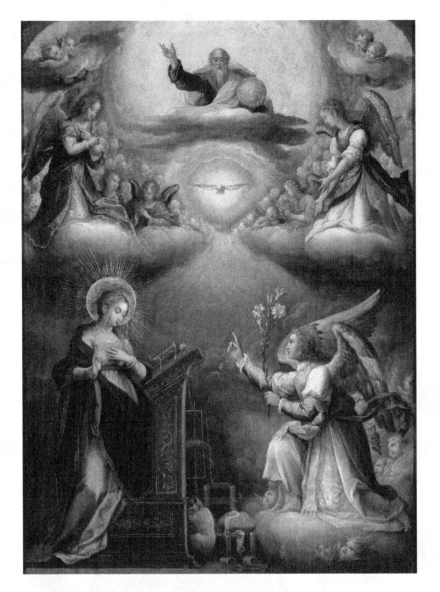

Hail Mary

Hail Mary, full of grace,
the Lord is with thee;
blessed are thou among women,
and blessed is the fruit of thy womb, Jesus.
Holy Mary, Mother of God,
pray for us sinners,
now and at the hour of our death.

Amen.

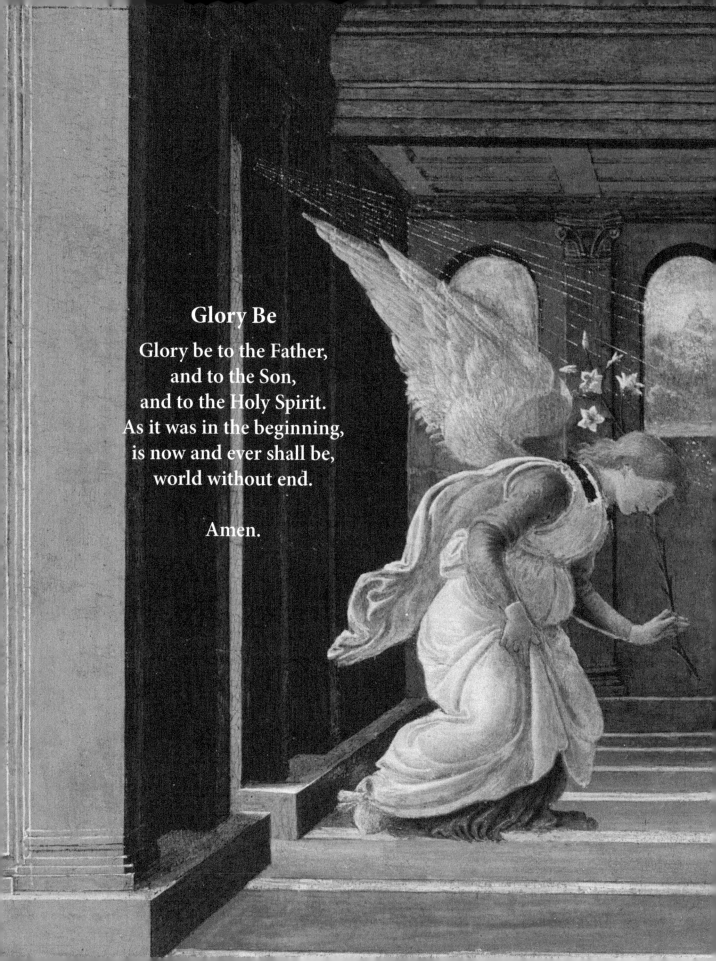

Glory Be

Glory be to the Father,
and to the Son,
and to the Holy Spirit.
As it was in the beginning,
is now and ever shall be,
world without end.

Amen.

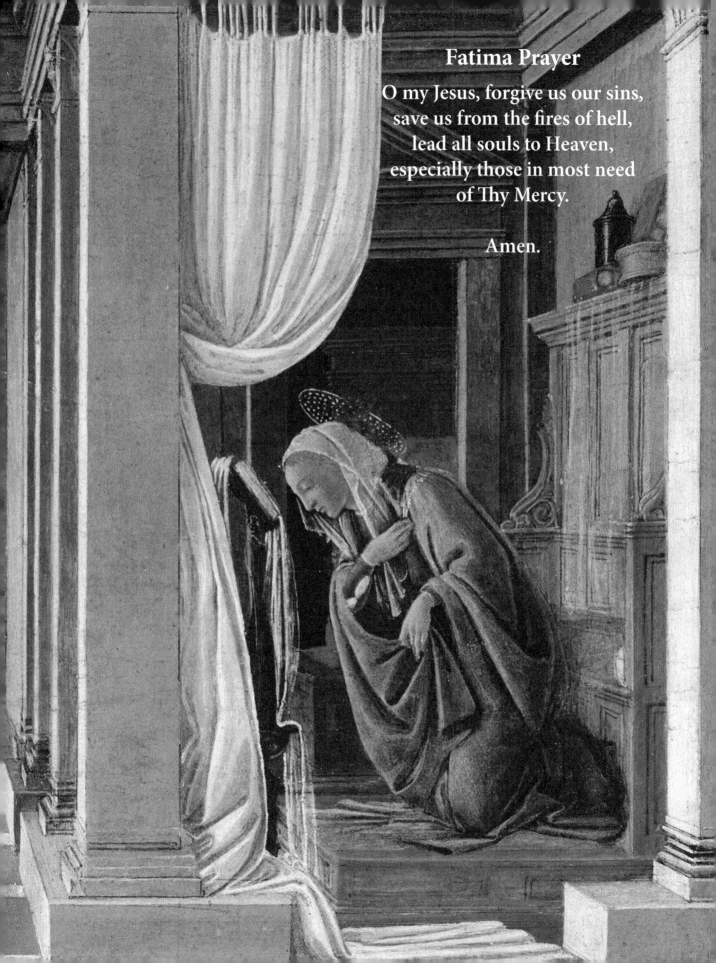

Fatima Prayer

O my Jesus, forgive us our sins,
save us from the fires of hell,
lead all souls to Heaven,
especially those in most need
of Thy Mercy.

Amen.

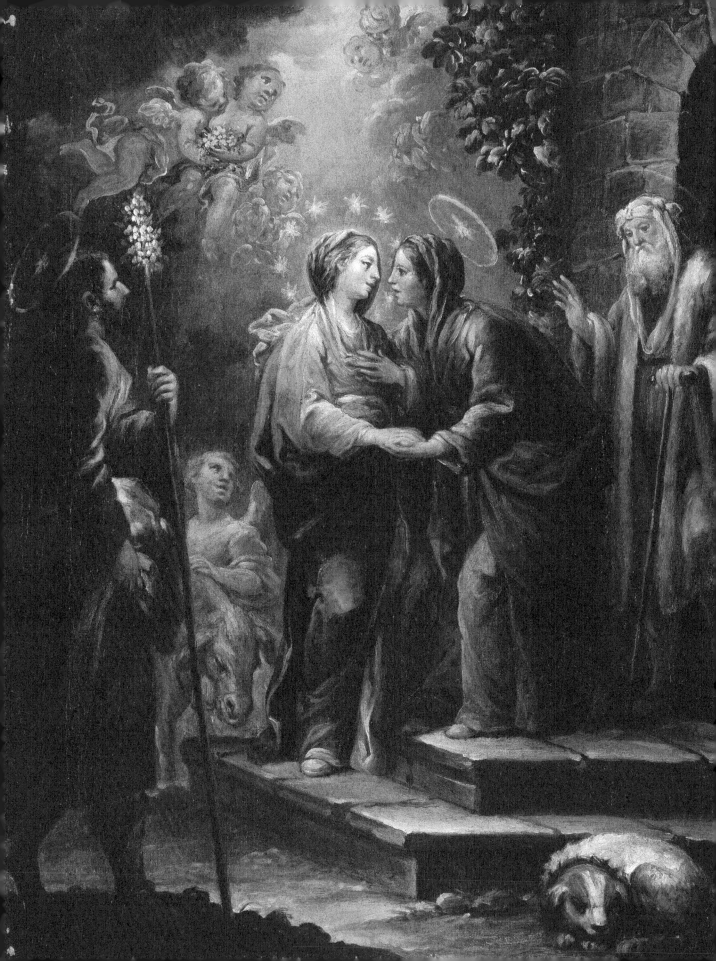

THE SECOND JOYFUL MYSTERY

The Visitation

Luke 1:39-56

Mary rising up in those days, went into the hill country with haste into a city of Juda. And she entered into the house of Zachary, and saluted Elizabeth. And it came to pass, that when Elizabeth heard the salutation of Mary, the infant leaped in her womb.

And Elizabeth was filled with the Holy Ghost: and she cried out with a loud voice, and said: Blessed art thou among women, and blessed is the fruit of thy womb. And whence is this to me, that the mother of my Lord should come to me? For behold as soon as the voice of thy salutation sounded in my ears, the infant in my womb leaped for joy. And blessed art thou that hast believed, because those things shall be accomplished that were spoken to thee by the Lord.

And Mary said: My soul doth magnify the Lord. And my spirit hath rejoiced in God my Saviour. Because he hath regarded the humility of his handmaid; for behold from henceforth all generations shall call me blessed. Because he that is mighty, hath done great things to me; and holy is his name. And his mercy is from generation unto generations, to them that fear him. He hath shewed might in his arm: he hath scattered the proud in the conceit of their heart. He hath put down the mighty from their seat, and hath exalted the humble. He hath filled the hungry with good things; and the rich he hath sent empty away. He hath received Israel his servant, being mindful of his mercy: As he spoke to our fathers, to Abraham and to his seed for ever.

And Mary abode with her about three months; and she returned to her own house.

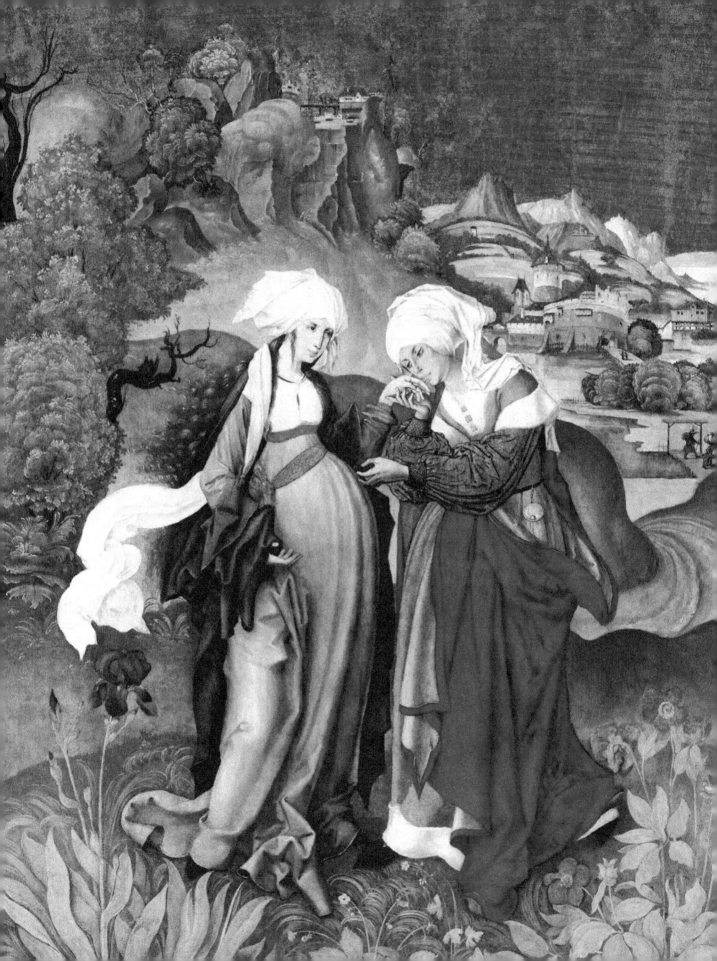

Our Father

Our Father, who art in heaven;
hallowed be Thy name;
Thy kingdom come;
Thy will be done on earth as it is in heaven.
Give us this day our daily bread;
and forgive us our trespasses
as we forgive those who trespass against us,
and lead us not into temptation;
but deliver us from evil.

Amen.

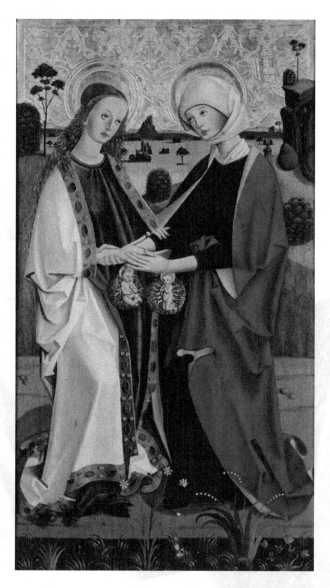

Hail Mary

Hail Mary, full of grace,
the Lord is with thee;
blessed are thou among women,
and blessed is the fruit of thy womb, Jesus.
Holy Mary, Mother of God,
pray for us sinners,
now and at the hour of our death.

Amen.

Hail Mary

Hail Mary, full of grace,
the Lord is with thee;
blessed are thou among women,
and blessed is the fruit of thy womb, Jesus.
Holy Mary, Mother of God,
pray for us sinners,
now and at the hour of our death.

Amen.

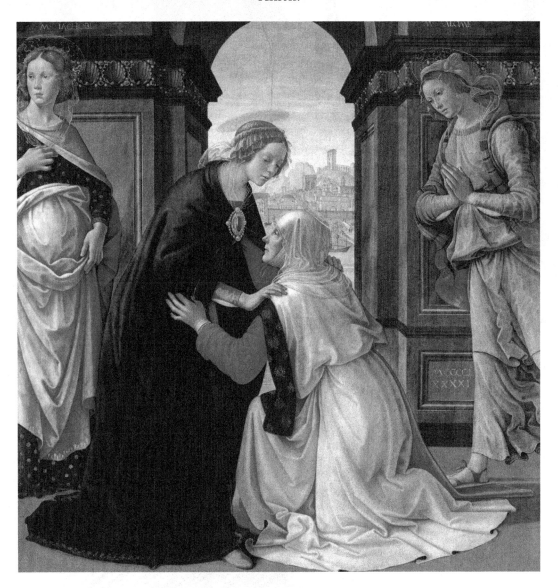

Hail Mary

Hail Mary, full of grace,
the Lord is with thee;
blessed are thou among women,
and blessed is the fruit of thy womb, Jesus.
Holy Mary, Mother of God,
pray for us sinners,
now and at the hour of our death.

Amen.

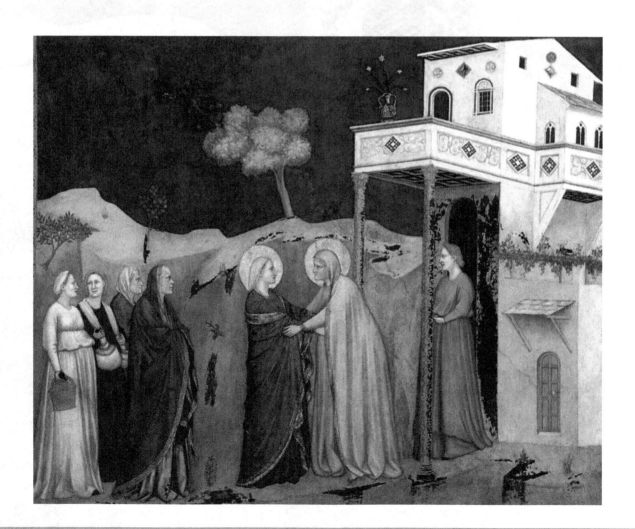

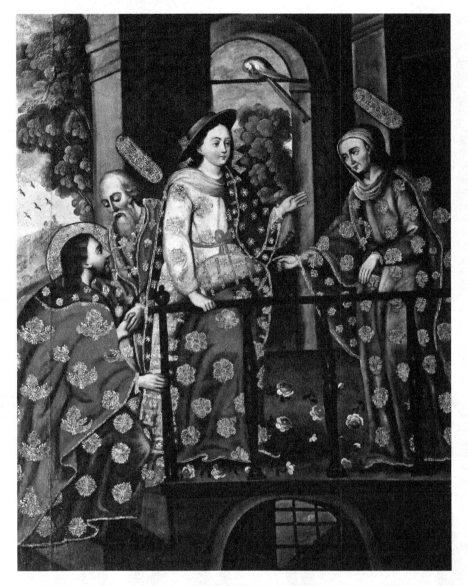

Hail Mary

Hail Mary, full of grace,
the Lord is with thee;
blessed are thou among women,
and blessed is the fruit of thy womb, Jesus.
Holy Mary, Mother of God,
pray for us sinners,
now and at the hour of our death.

Amen.

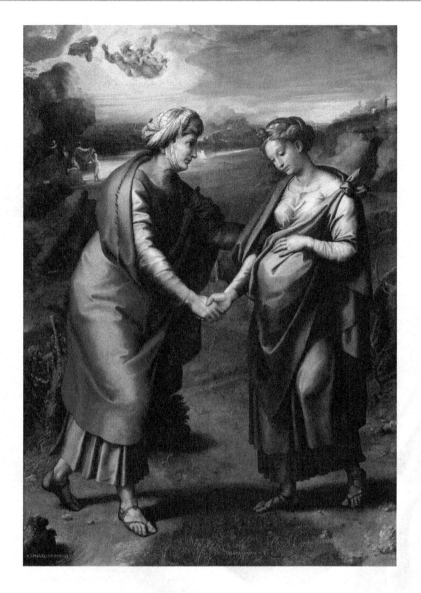

Hail Mary

Hail Mary, full of grace,
the Lord is with thee;
blessed are thou among women,
and blessed is the fruit of thy womb, Jesus.
Holy Mary, Mother of God,
pray for us sinners,
now and at the hour of our death.

Amen.

Hail Mary

Hail Mary, full of grace,
the Lord is with thee;
blessed are thou among women,
and blessed is the fruit of thy womb, Jesus.
Holy Mary, Mother of God,
pray for us sinners,
now and at the hour of our death.

Amen.

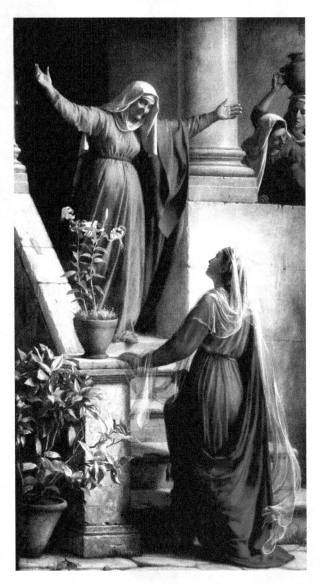

Hail Mary

Hail Mary, full of grace,
the Lord is with thee;
blessed are thou among women,
and blessed is the fruit of thy womb, Jesus.
Holy Mary, Mother of God,
pray for us sinners,
now and at the hour of our death.

Amen.

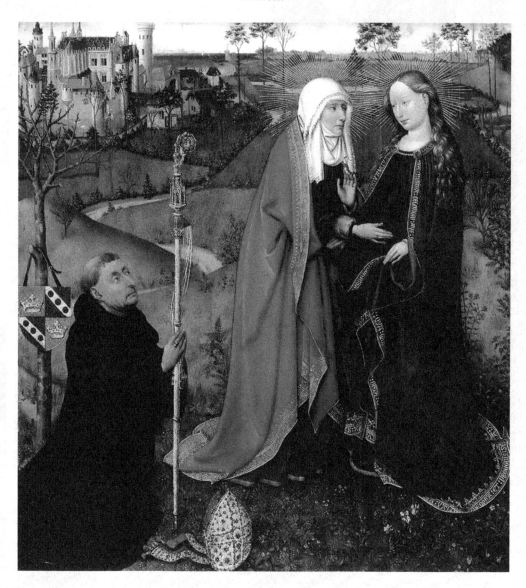

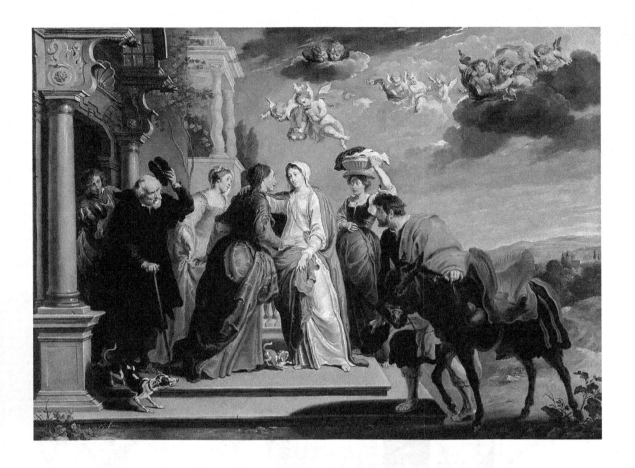

Hail Mary

Hail Mary, full of grace,
the Lord is with thee;
blessed are thou among women,
and blessed is the fruit of thy womb, Jesus.
Holy Mary, Mother of God,
pray for us sinners,
now and at the hour of our death.

Amen.

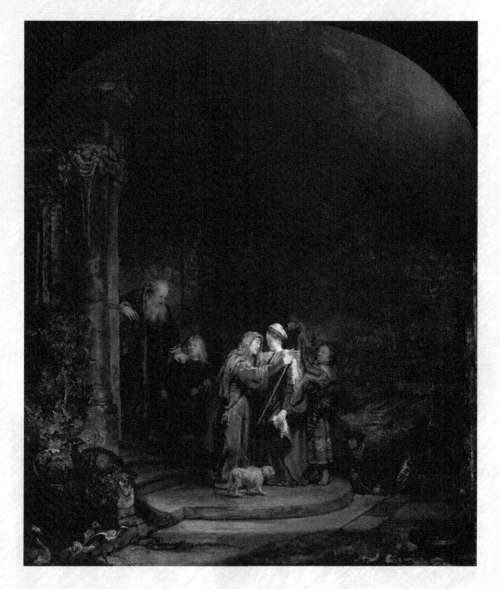

Hail Mary

Hail Mary, full of grace,
the Lord is with thee;
blessed are thou among women,
and blessed is the fruit of thy womb, Jesus.
Holy Mary, Mother of God,
pray for us sinners,
now and at the hour of our death.

Amen.

Hail Mary

Hail Mary, full of grace,
the Lord is with thee;
blessed are thou among women,
and blessed is the fruit of thy womb, Jesus.
Holy Mary, Mother of God,
pray for us sinners,
now and at the hour of our death.

Amen.

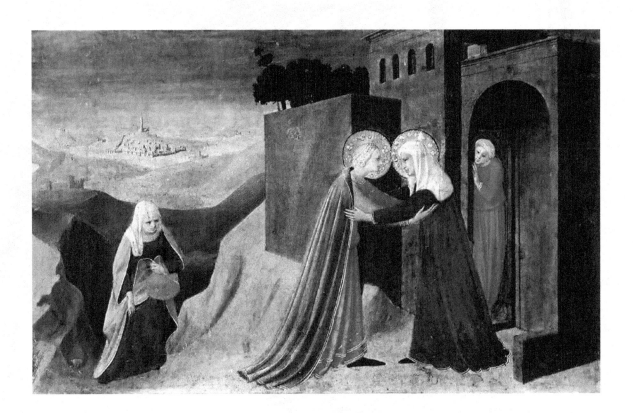

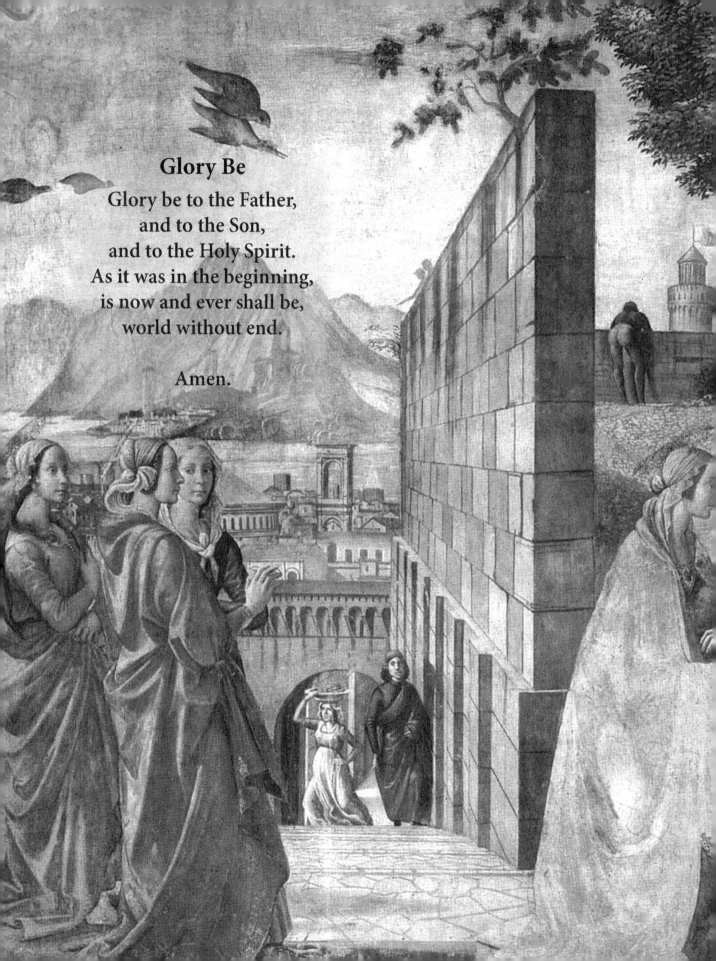

Glory Be

Glory be to the Father,
and to the Son,
and to the Holy Spirit.
As it was in the beginning,
is now and ever shall be,
world without end.

Amen.

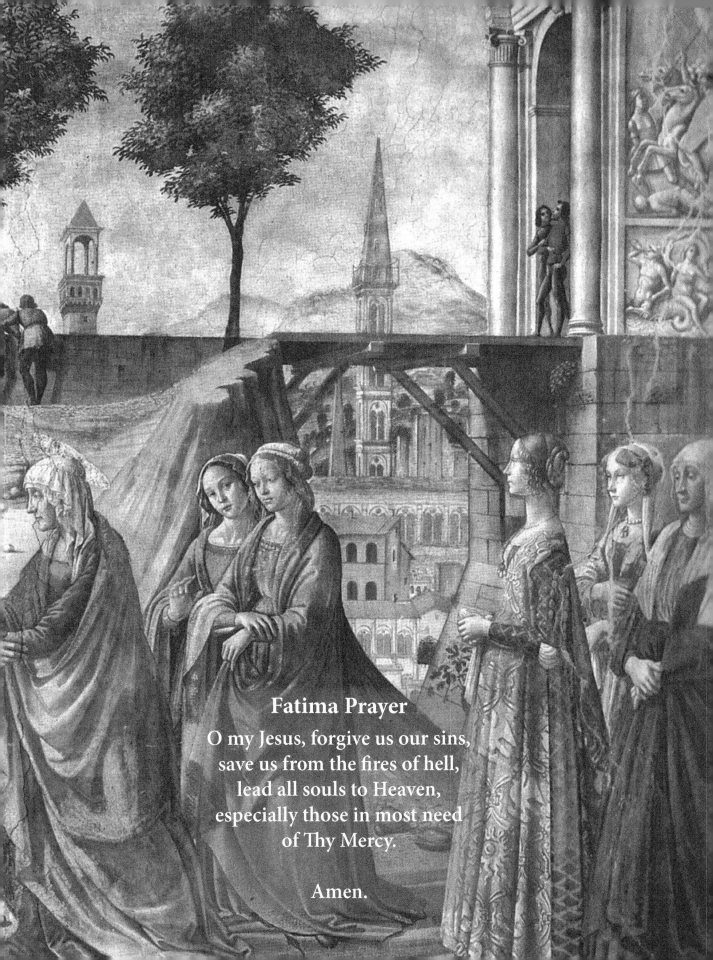

Fatima Prayer
O my Jesus, forgive us our sins,
save us from the fires of hell,
lead all souls to Heaven,
especially those in most need
of Thy Mercy.

Amen.

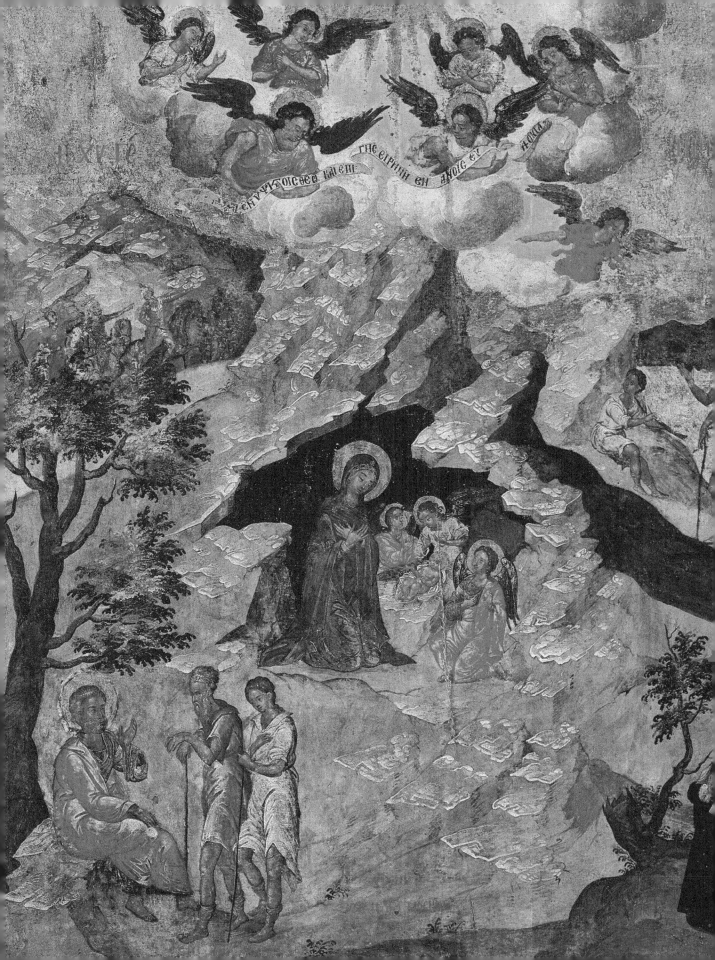

The Birth of Our Lord Jesus Christ

Luke 2:1-20

It came to pass, that in those days there went out a decree from Caesar Augustus, that the whole world should be enrolled. This enrolling was first made by Cyrinus, the governor of Syria. And all went to be enrolled, every one into his own city. And Joseph also went up from Galilee, out of the city of Nazareth into Judea, to the city of David, which is called Bethlehem: because he was of the house and family of David, to be enrolled with Mary his espoused wife, who was with child.

And it came to pass, that when they were there, her days were accomplished, that she should be delivered. And she brought forth her firstborn son, and wrapped him up in swaddling clothes, and laid him in a manger; because there was no room for them in the inn.

And there were in the same country shepherds watching, and keeping the night watches over their flock. And behold an angel of the Lord stood by them, and the brightness of God shone round about them; and they feared with a great fear.

And the angel said to them: Fear not; for, behold, I bring you good tidings of great joy, that shall be to all the people: For, this day, is born to you a Saviour, who is Christ the Lord, in the city of David. And this shall be a sign unto you. You shall find the infant wrapped in swaddling clothes, and laid in a manger.

And suddenly there was with the angel a multitude of the heavenly army, praising God, and saying: Glory to God in the highest; and on earth peace to men of good will.

And it came to pass, after the angels departed from them into heaven, the shepherds said one to another: Let us go over to Bethlehem, and let us see this word that is come to pass, which the Lord hath shewed to us.

And they came with haste; and they found Mary and Joseph, and the infant lying in the manger. And seeing, they understood of the word that had been spoken to them concerning this child. And all that heard, wondered; and at those things that were told them by the shepherds. But Mary kept all these words, pondering them in her heart.

And the shepherds returned, glorifying and praising God, for all the things they had heard and seen, as it was told unto them.

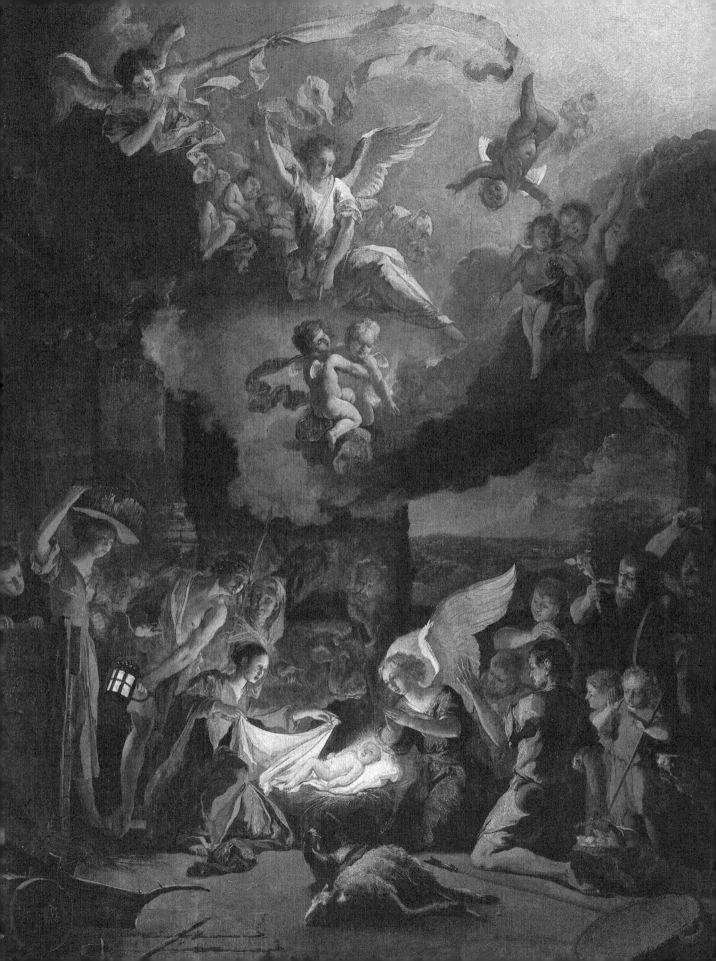

Our Father

Our Father, who art in heaven;
hallowed be Thy name;
Thy kingdom come;
Thy will be done on earth as it is in heaven.
Give us this day our daily bread;
and forgive us our trespasses
as we forgive those who trespass against us,
and lead us not into temptation;
but deliver us from evil.

Amen.

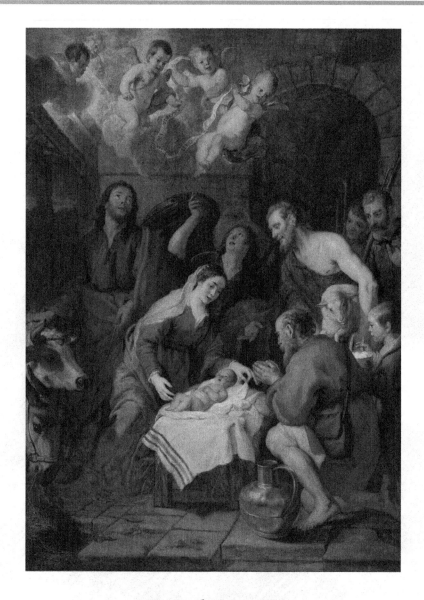

Hail Mary

Hail Mary, full of grace,
the Lord is with thee;
blessed are thou among women,
and blessed is the fruit of thy womb, Jesus.
Holy Mary, Mother of God,
pray for us sinners,
now and at the hour of our death.

Amen.

Hail Mary

Hail Mary, full of grace,
the Lord is with thee;
blessed are thou among women,
and blessed is the fruit of thy womb, Jesus.
Holy Mary, Mother of God,
pray for us sinners,
now and at the hour of our death.

Amen.

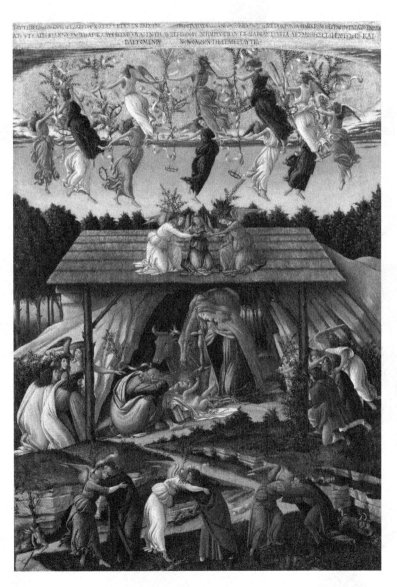

Hail Mary

Hail Mary, full of grace,
the Lord is with thee;
blessed are thou among women,
and blessed is the fruit of thy womb, Jesus.
Holy Mary, Mother of God,
pray for us sinners,
now and at the hour of our death.

Amen.

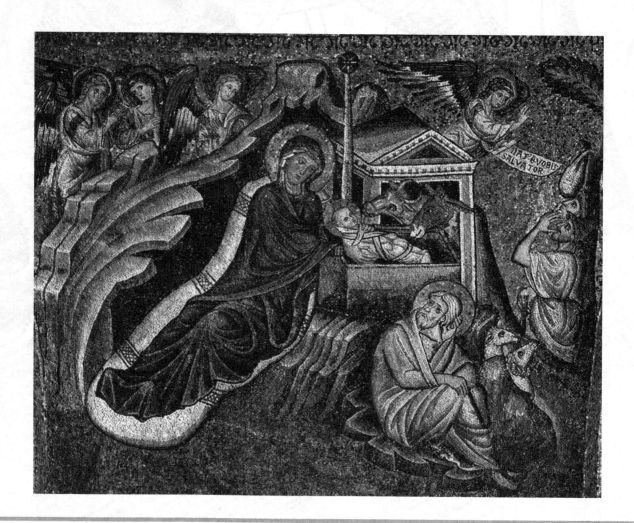

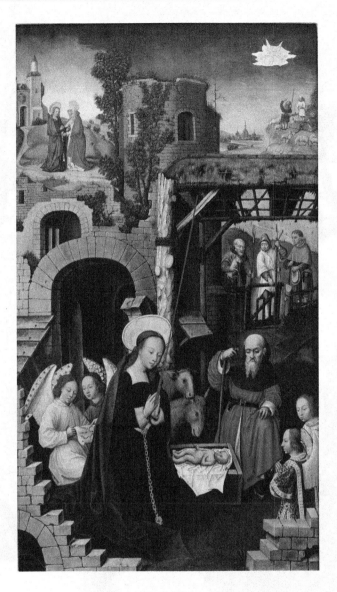

Hail Mary

Hail Mary, full of grace,
the Lord is with thee;
blessed are thou among women,
and blessed is the fruit of thy womb, Jesus.
Holy Mary, Mother of God,
pray for us sinners,
now and at the hour of our death.

Amen.

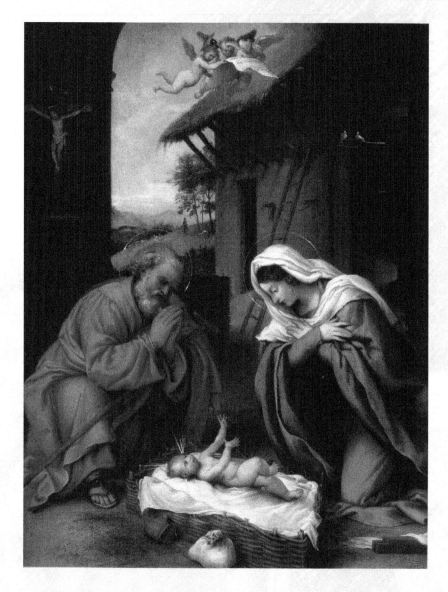

Hail Mary

Hail Mary, full of grace,
the Lord is with thee;
blessed are thou among women,
and blessed is the fruit of thy womb, Jesus.
Holy Mary, Mother of God,
pray for us sinners,
now and at the hour of our death.

Amen.

Hail Mary

Hail Mary, full of grace,
the Lord is with thee;
blessed are thou among women,
and blessed is the fruit of thy womb, Jesus.
Holy Mary, Mother of God,
pray for us sinners,
now and at the hour of our death.

Amen.

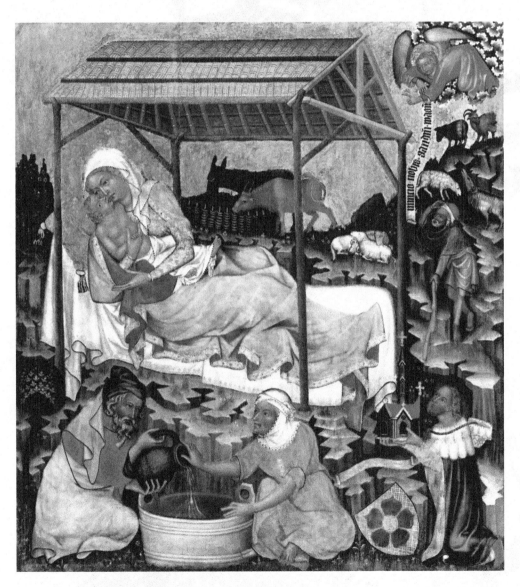

Hail Mary

Hail Mary, full of grace,
the Lord is with thee;
blessed are thou among women,
and blessed is the fruit of thy womb, Jesus.
Holy Mary, Mother of God,
pray for us sinners,
now and at the hour of our death.

Amen.

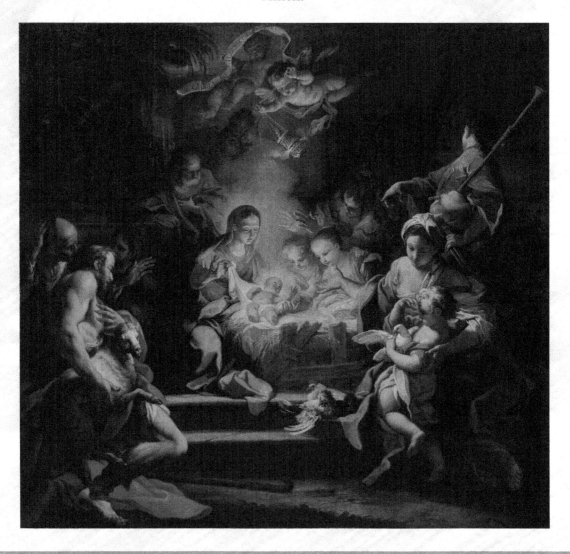

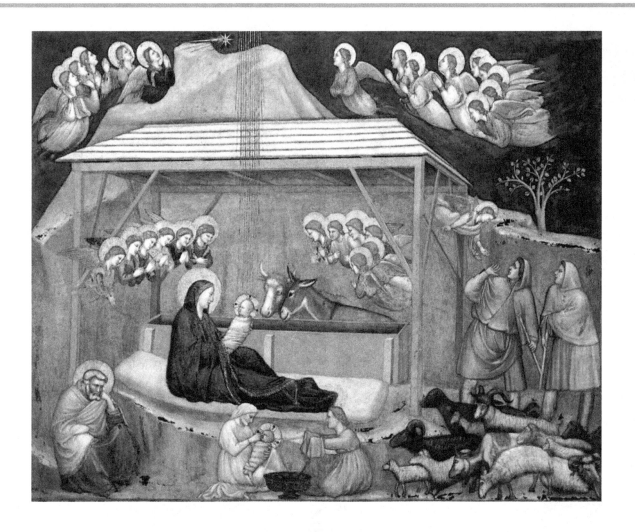

Hail Mary

Hail Mary, full of grace,
the Lord is with thee;
blessed are thou among women,
and blessed is the fruit of thy womb, Jesus.
Holy Mary, Mother of God,
pray for us sinners,
now and at the hour of our death.

Amen.

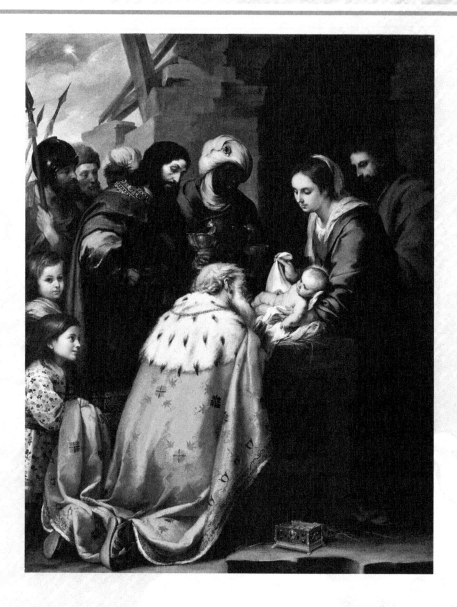

Hail Mary

Hail Mary, full of grace,
the Lord is with thee;
blessed are thou among women,
and blessed is the fruit of thy womb, Jesus.
Holy Mary, Mother of God,
pray for us sinners,
now and at the hour of our death.

Amen.

Hail Mary

Hail Mary, full of grace,
the Lord is with thee;
blessed are thou among women,
and blessed is the fruit of thy womb, Jesus.
Holy Mary, Mother of God,
pray for us sinners,
now and at the hour of our death.

Amen.

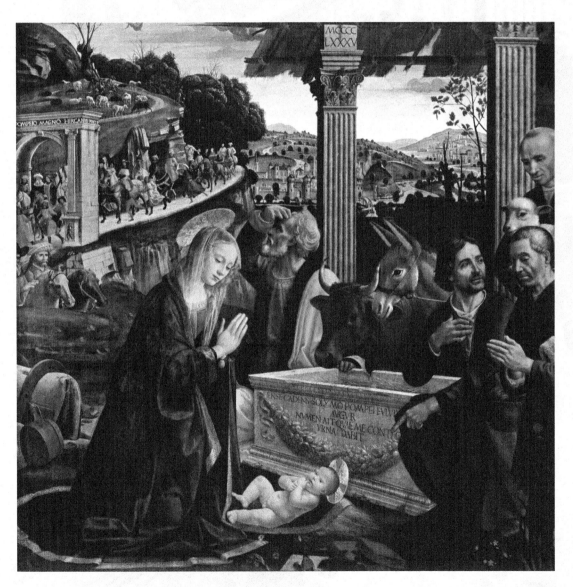

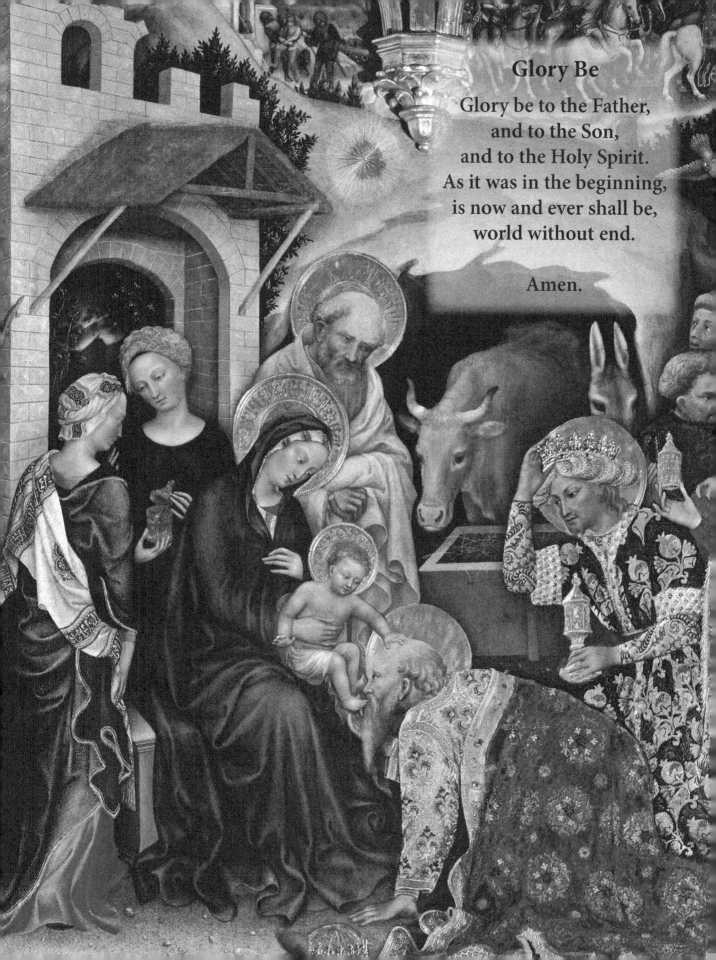

Glory Be

Glory be to the Father,
and to the Son,
and to the Holy Spirit.
As it was in the beginning,
is now and ever shall be,
world without end.

Amen.

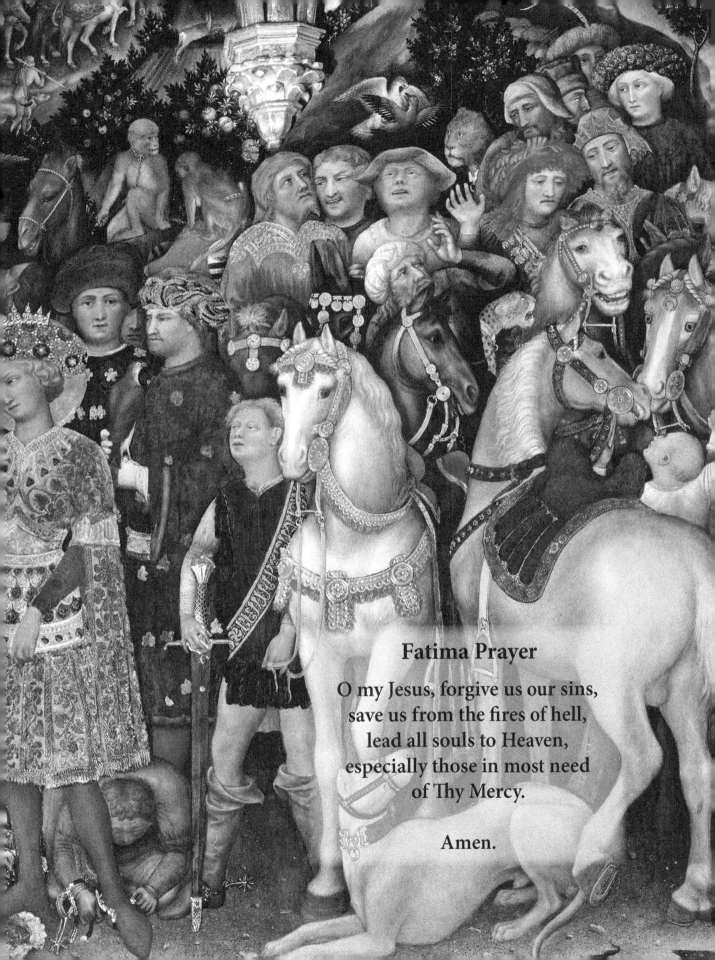

Fatima Prayer

O my Jesus, forgive us our sins,
save us from the fires of hell,
lead all souls to Heaven,
especially those in most need
of Thy Mercy.

Amen.

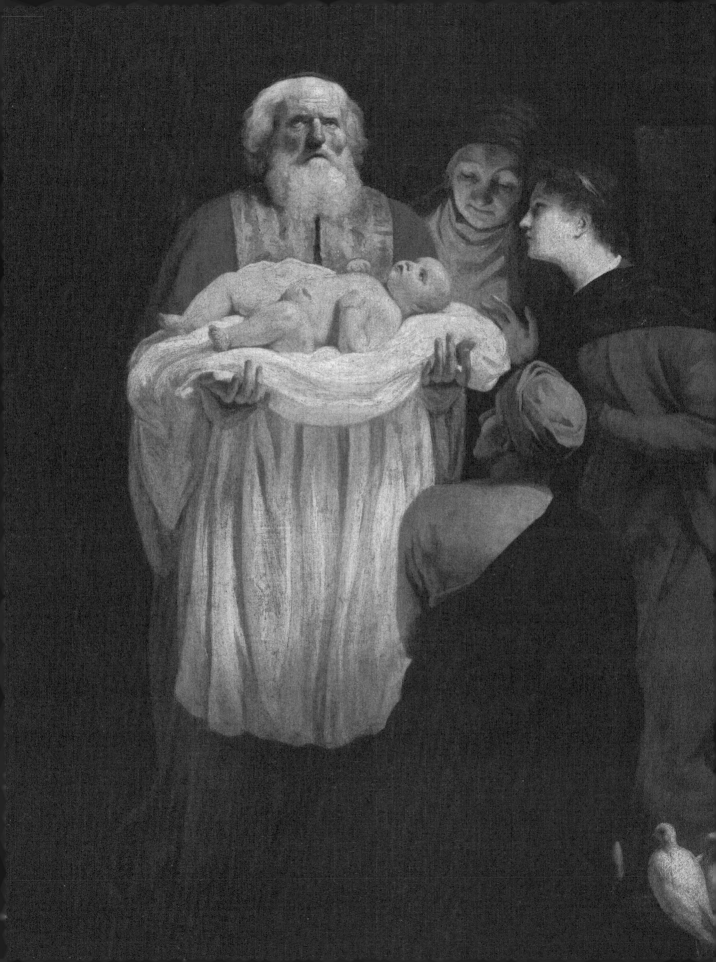

THE FOURTH JOYFUL MYSTERY

The Presentation

Luke 2:22-38

fter the days of her purification, according to the law of Moses, were accomplished, they carried him to Jerusalem, to present him to the Lord: as it is written in the law of the Lord: Every male opening the womb shall be called holy to the Lord: And to offer a sacrifice, according as it is written in the law of the Lord, a pair of turtledoves, or two young pigeons:

And behold there was a man in Jerusalem named Simeon, and this man was just and devout, waiting for the consolation of Israel; and the Holy Ghost was in him. And he had received an answer from the Holy Ghost, that he should not see death, before he had seen the Christ of the Lord.

And he came by the Spirit into the temple. And when his parents brought in the child Jesus, to do for him according to the custom of the law, he also took him into his arms, and blessed God, and said: Now thou dost dismiss thy servant, O Lord, according to thy word in peace; because my eyes have seen thy salvation, which thou hast prepared before the face of all peoples: a light to the revelation of the Gentiles, and the glory of thy people Israel.

And his father and mother were wondering at those things which were spoken concerning him. And Simeon blessed them, and said to Mary his mother: Behold this child is set for the fall, and for the resurrection of many in Israel, and for a sign which shall be contradicted; And thy own soul a sword shall pierce, that, out of many hearts, thoughts may be revealed.

And there was one Anna, a prophetess, the daughter of Phanuel, of the tribe of Aser; she was far advanced in years, and had lived with her husband seven years from her virginity. And she was a widow until fourscore and four years; who departed not from the temple, by fastings and prayers serving night and day. Now she, at the same hour, coming in, confessed to the Lord; and spoke of him to all that looked for the redemption of Israel.

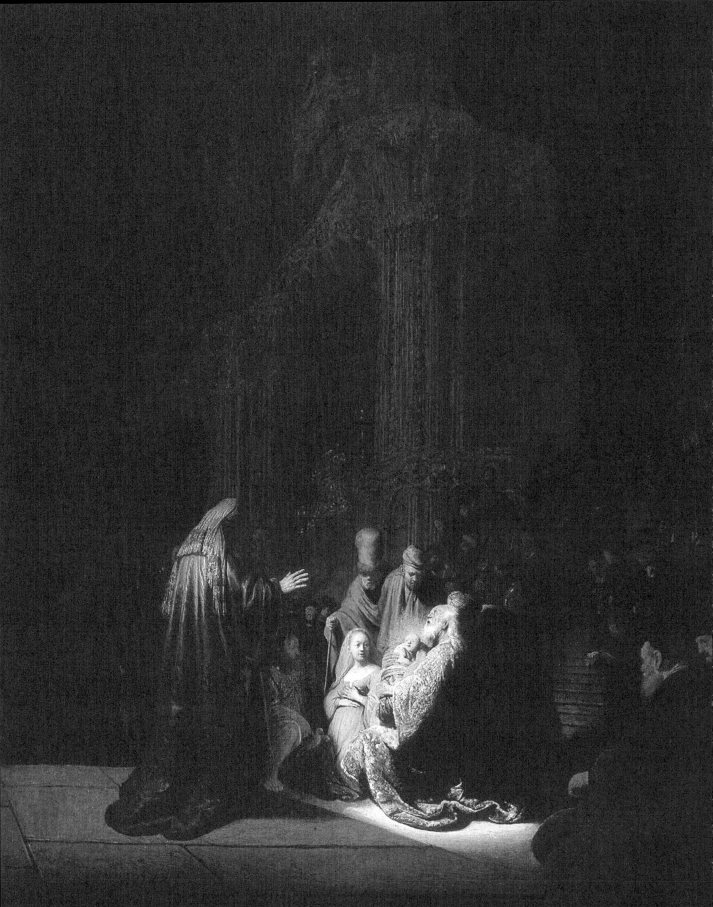

Our Father

Our Father, who art in heaven;
hallowed be Thy name;
Thy kingdom come;
Thy will be done on earth as it is in heaven.
Give us this day our daily bread;
and forgive us our trespasses
as we forgive those who trespass against us,
and lead us not into temptation;
but deliver us from evil.

Amen.

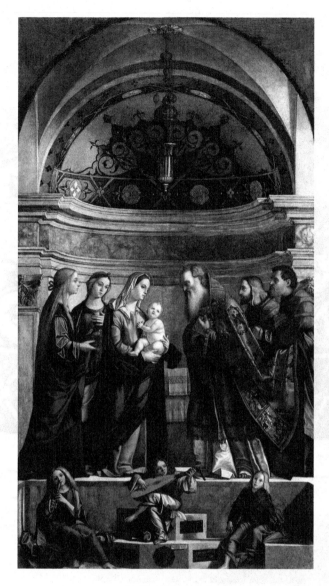

Hail Mary

Hail Mary, full of grace,
the Lord is with thee;
blessed are thou among women,
and blessed is the fruit of thy womb, Jesus.
Holy Mary, Mother of God,
pray for us sinners,
now and at the hour of our death.

Amen.

Hail Mary

Hail Mary, full of grace,
the Lord is with thee;
blessed are thou among women,
and blessed is the fruit of thy womb, Jesus.
Holy Mary, Mother of God,
pray for us sinners,
now and at the hour of our death.

Amen.

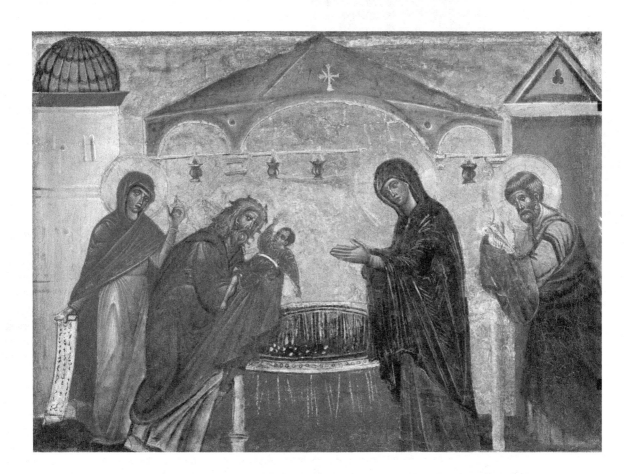

Hail Mary

Hail Mary, full of grace,
the Lord is with thee;
blessed are thou among women,
and blessed is the fruit of thy womb, Jesus.
Holy Mary, Mother of God,
pray for us sinners,
now and at the hour of our death.

Amen.

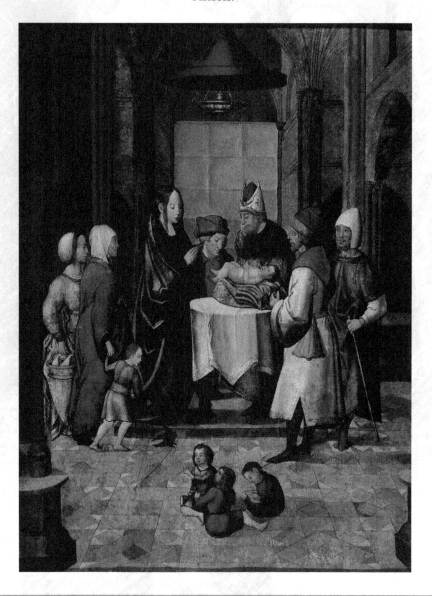

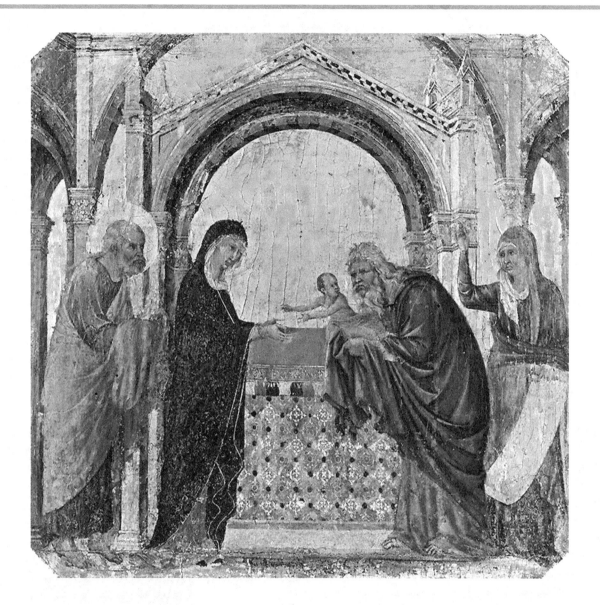

Hail Mary

Hail Mary, full of grace,
the Lord is with thee;
blessed are thou among women,
and blessed is the fruit of thy womb, Jesus.
Holy Mary, Mother of God,
pray for us sinners,
now and at the hour of our death.

Amen.

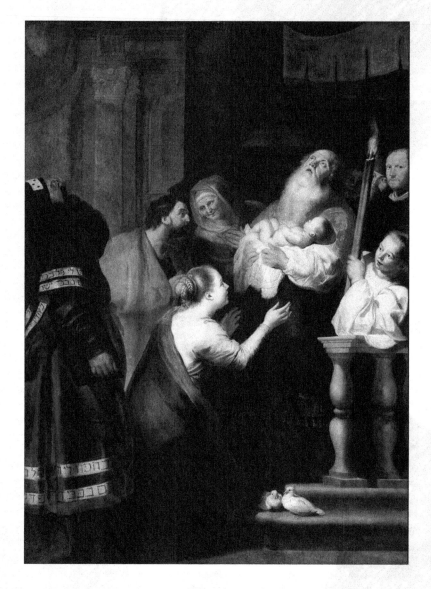

Hail Mary

Hail Mary, full of grace,
the Lord is with thee;
blessed are thou among women,
and blessed is the fruit of thy womb, Jesus.
Holy Mary, Mother of God,
pray for us sinners,
now and at the hour of our death.

Amen.

Hail Mary

Hail Mary, full of grace,
the Lord is with thee;
blessed are thou among women,
and blessed is the fruit of thy womb, Jesus.
Holy Mary, Mother of God,
pray for us sinners,
now and at the hour of our death.

Amen.

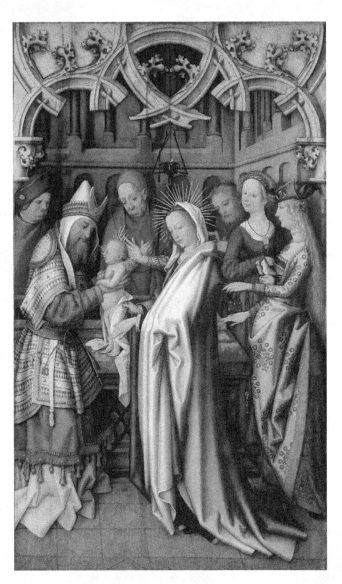

Hail Mary

Hail Mary, full of grace,
the Lord is with thee;
blessed are thou among women,
and blessed is the fruit of thy womb, Jesus.
Holy Mary, Mother of God,
pray for us sinners,
now and at the hour of our death.

Amen.

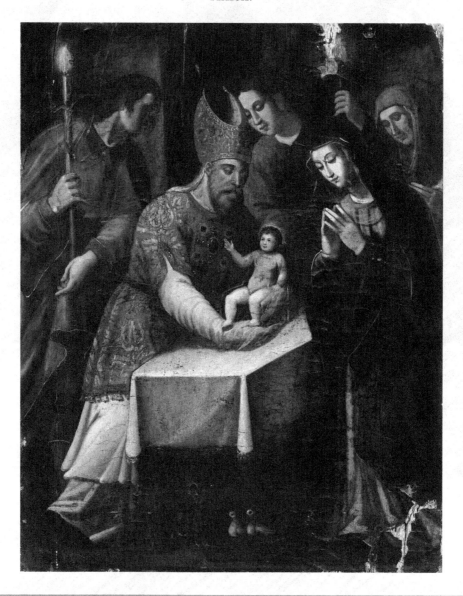

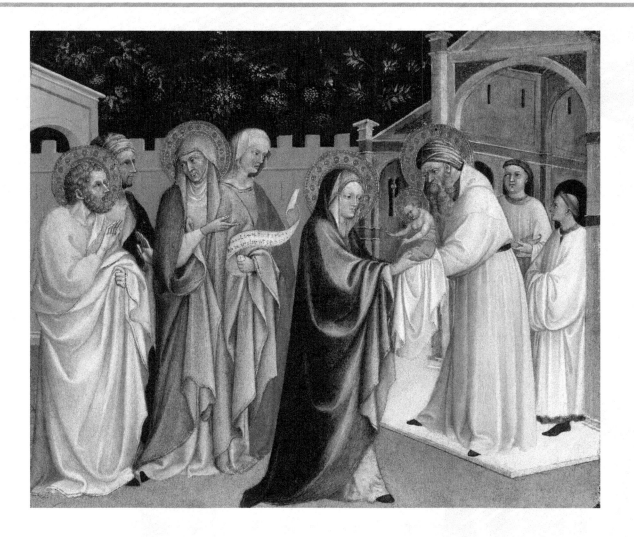

Hail Mary

Hail Mary, full of grace,
the Lord is with thee;
blessed are thou among women,
and blessed is the fruit of thy womb, Jesus.
Holy Mary, Mother of God,
pray for us sinners,
now and at the hour of our death.

Amen.

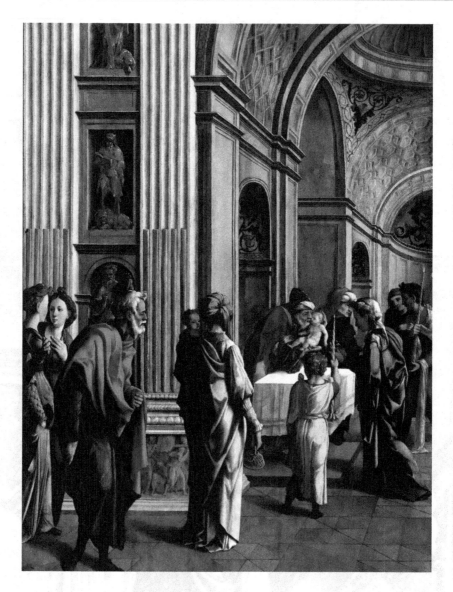

Hail Mary

Hail Mary, full of grace,
the Lord is with thee;
blessed are thou among women,
and blessed is the fruit of thy womb, Jesus.
Holy Mary, Mother of God,
pray for us sinners,
now and at the hour of our death.

Amen.

Hail Mary

Hail Mary, full of grace,
the Lord is with thee;
blessed are thou among women,
and blessed is the fruit of thy womb, Jesus.
Holy Mary, Mother of God,
pray for us sinners,
now and at the hour of our death.

Amen.

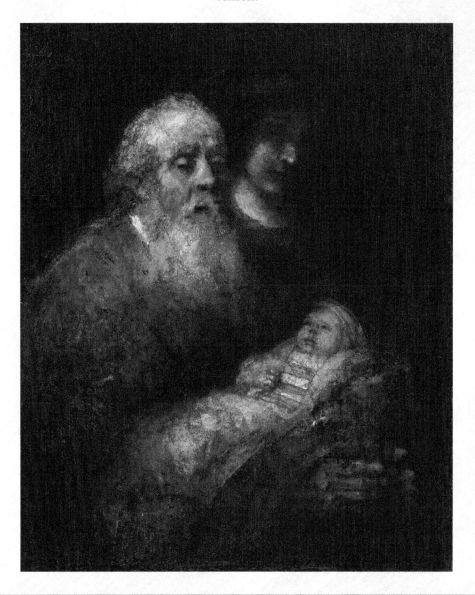

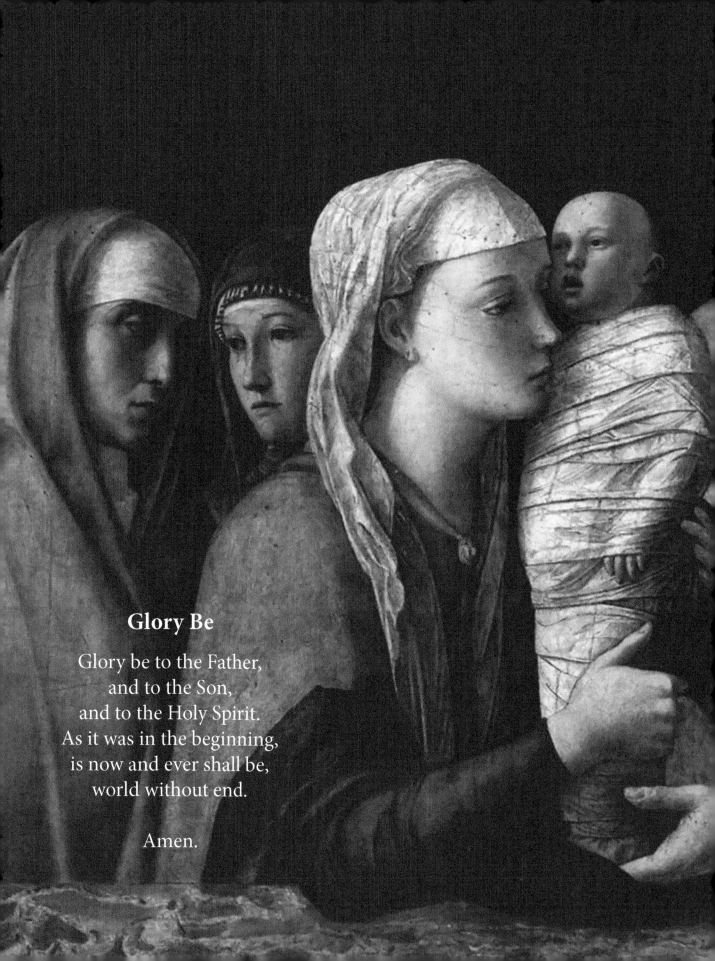

Glory Be

Glory be to the Father,
and to the Son,
and to the Holy Spirit.
As it was in the beginning,
is now and ever shall be,
world without end.

Amen.

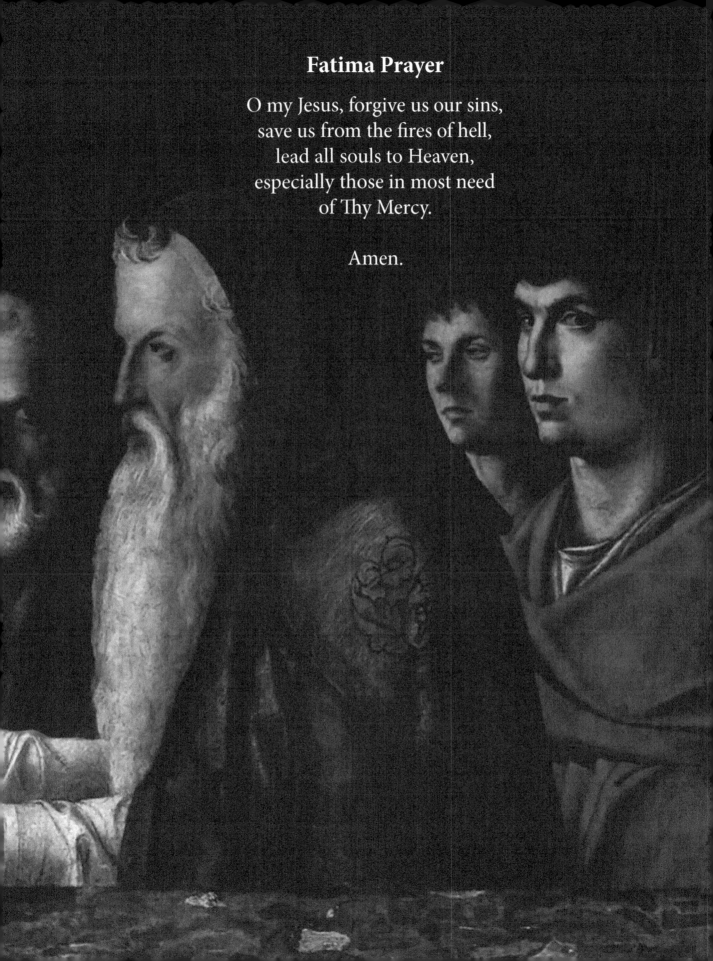

Fatima Prayer

O my Jesus, forgive us our sins,
save us from the fires of hell,
lead all souls to Heaven,
especially those in most need
of Thy Mercy.

Amen.

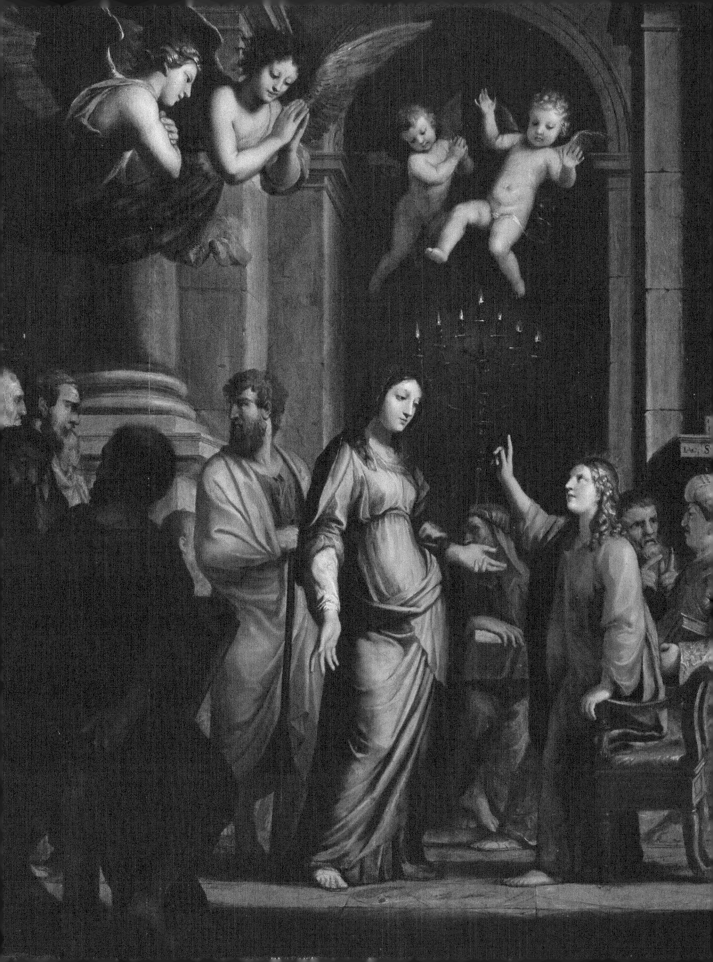

The Finding of Christ in the Temple

Luke 2:41-52

nd his parents went every year to Jerusalem, at the solemn day of the pasch, And when he was twelve years old, they going up into Jerusalem, according to the custom of the feast, and having fulfilled the days, when they returned, the child Jesus remained in Jerusalem; and his parents knew it not. And thinking that he was in the company, they came a day's journey, and sought him among their kinsfolks and acquaintance. And not finding him, they returned into Jerusalem, seeking him.

And it came to pass, that, after three days, they found him in the temple, sitting in the midst of the doctors, hearing them, and asking them questions. And all that heard him were astonished at his wisdom and his answers.

And seeing him, they wondered. And his mother said to him: Son, why hast thou done so to us? behold thy father and I have sought thee sorrowing.

And he said to them: How is it that you sought me? did you not know, that I must be about my father's business?

And they understood not the word that he spoke unto them.

And he went down with them, and came to Nazareth, and was subject to them. And his mother kept all these words in her heart. And Jesus advanced in wisdom, and age, and grace with God and men.

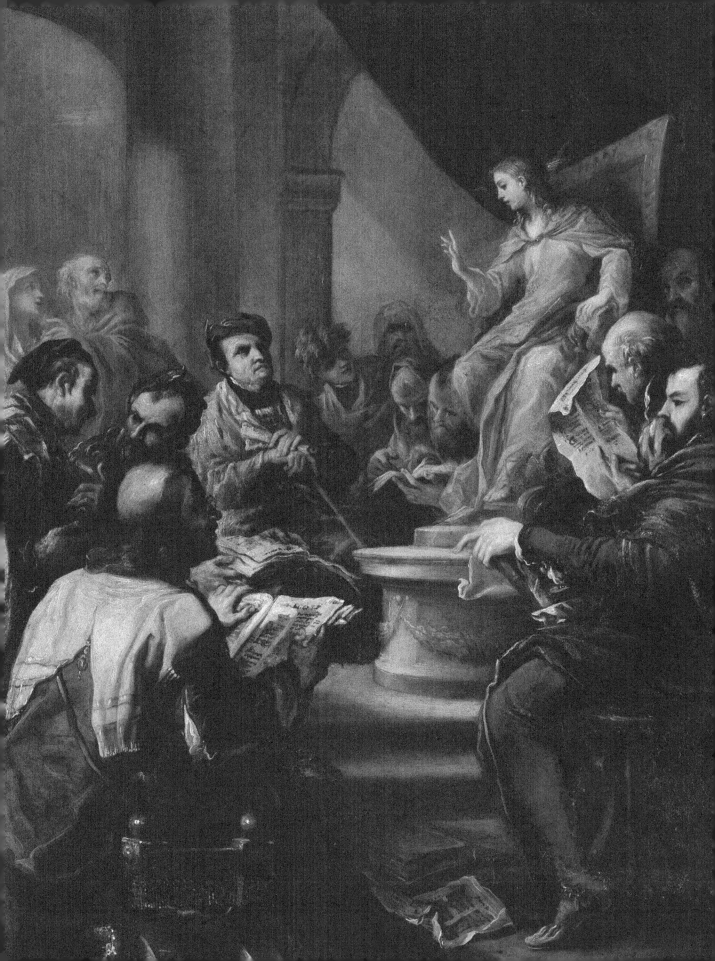

Our Father

Our Father, who art in heaven;
hallowed be Thy name;
Thy kingdom come;
Thy will be done on earth as it is in heaven.
Give us this day our daily bread;
and forgive us our trespasses
as we forgive those who trespass against us,
and lead us not into temptation;
but deliver us from evil.

Amen.

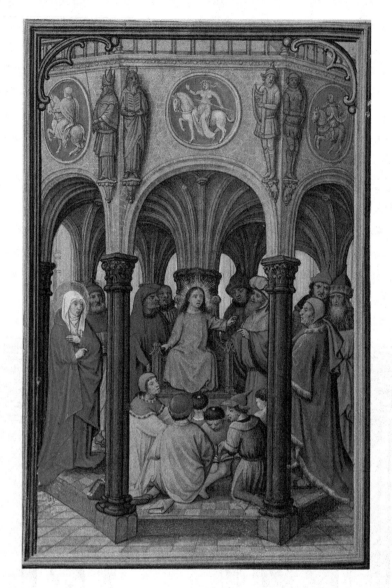

Hail Mary

Hail Mary, full of grace,
the Lord is with thee;
blessed are thou among women,
and blessed is the fruit of thy womb, Jesus.
Holy Mary, Mother of God,
pray for us sinners,
now and at the hour of our death.

Amen.

Hail Mary

Hail Mary, full of grace,
the Lord is with thee;
blessed are thou among women,
and blessed is the fruit of thy womb, Jesus.
Holy Mary, Mother of God,
pray for us sinners,
now and at the hour of our death.

Amen.

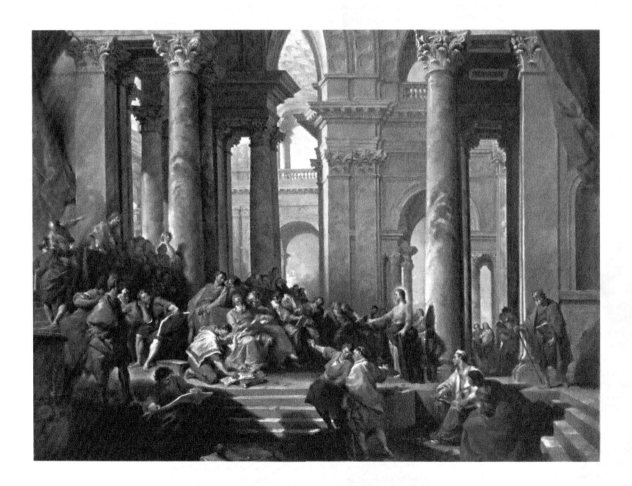

Hail Mary

Hail Mary, full of grace,
the Lord is with thee;
blessed are thou among women,
and blessed is the fruit of thy womb, Jesus.
Holy Mary, Mother of God,
pray for us sinners,
now and at the hour of our death.

Amen.

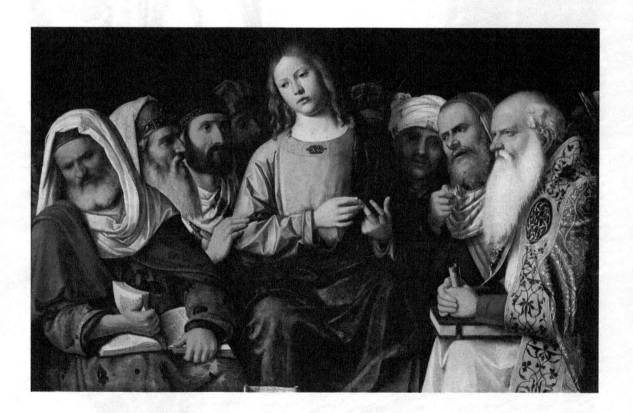

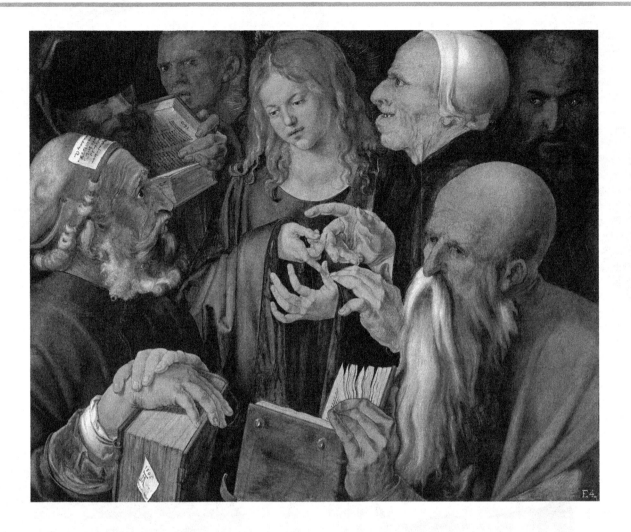

Hail Mary

Hail Mary, full of grace,
the Lord is with thee;
blessed are thou among women,
and blessed is the fruit of thy womb, Jesus.
Holy Mary, Mother of God,
pray for us sinners,
now and at the hour of our death.

Amen.

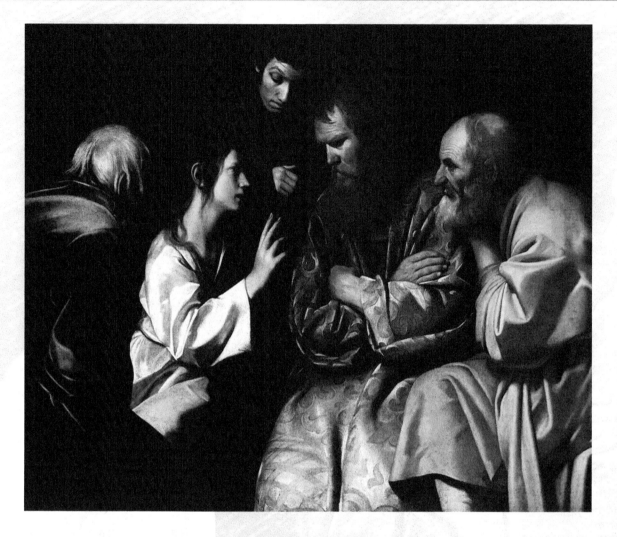

Hail Mary

Hail Mary, full of grace,
the Lord is with thee;
blessed are thou among women,
and blessed is the fruit of thy womb, Jesus.
Holy Mary, Mother of God,
pray for us sinners,
now and at the hour of our death.

Amen.

Hail Mary

Hail Mary, full of grace,
the Lord is with thee;
blessed are thou among women,
and blessed is the fruit of thy womb, Jesus.
Holy Mary, Mother of God,
pray for us sinners,
now and at the hour of our death.

Amen.

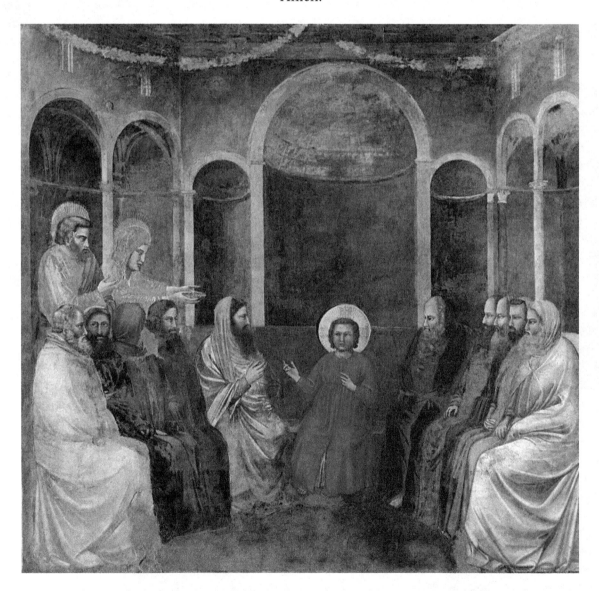

Hail Mary

Hail Mary, full of grace,
the Lord is with thee;
blessed are thou among women,
and blessed is the fruit of thy womb, Jesus.
Holy Mary, Mother of God,
pray for us sinners,
now and at the hour of our death.

Amen.

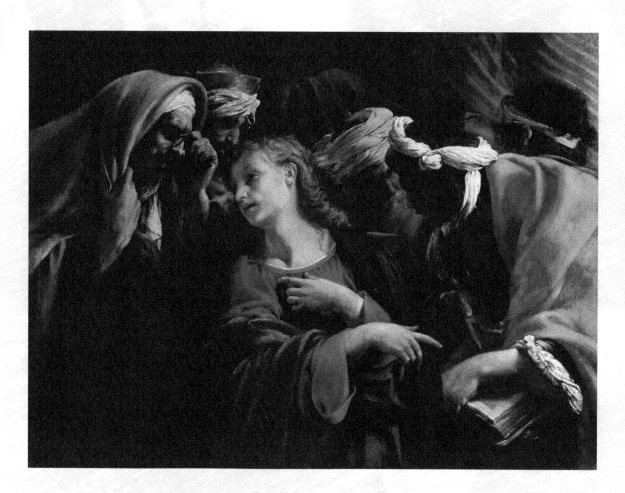

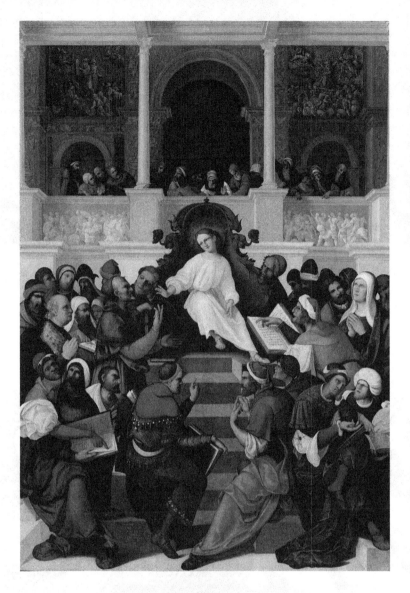

Hail Mary

Hail Mary, full of grace,
the Lord is with thee;
blessed are thou among women,
and blessed is the fruit of thy womb, Jesus.
Holy Mary, Mother of God,
pray for us sinners,
now and at the hour of our death.

Amen.

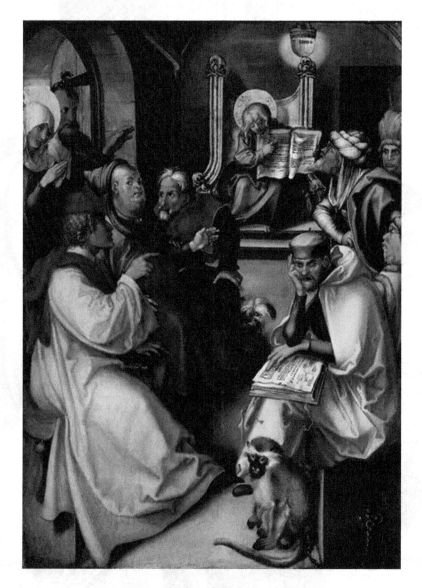

Hail Mary

Hail Mary, full of grace,
the Lord is with thee;
blessed are thou among women,
and blessed is the fruit of thy womb, Jesus.
Holy Mary, Mother of God,
pray for us sinners,
now and at the hour of our death.

Amen.

Hail Mary

Hail Mary, full of grace,
the Lord is with thee;
blessed are thou among women,
and blessed is the fruit of thy womb, Jesus.
Holy Mary, Mother of God,
pray for us sinners,
now and at the hour of our death.

Amen.

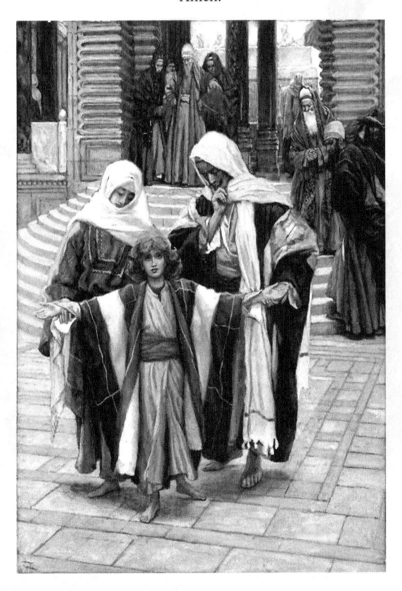

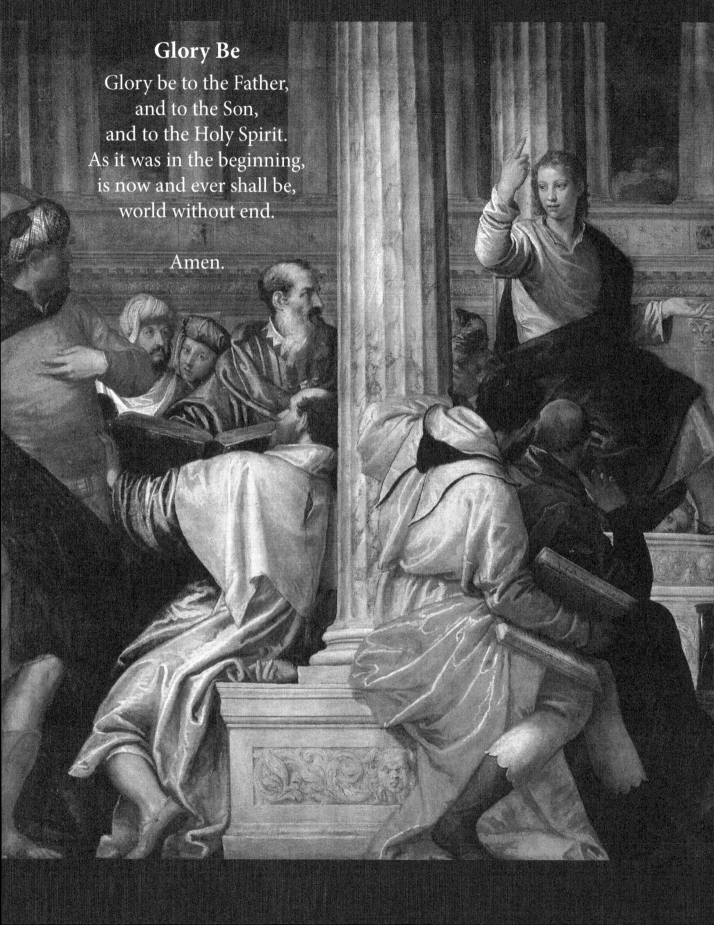

Glory Be

Glory be to the Father,
and to the Son,
and to the Holy Spirit.
As it was in the beginning,
is now and ever shall be,
world without end.

Amen.

Fatima Prayer

O my Jesus, forgive us our sins,
save us from the fires of hell,
lead all souls to Heaven,
especially those in most need
of Thy Mercy.

Amen.

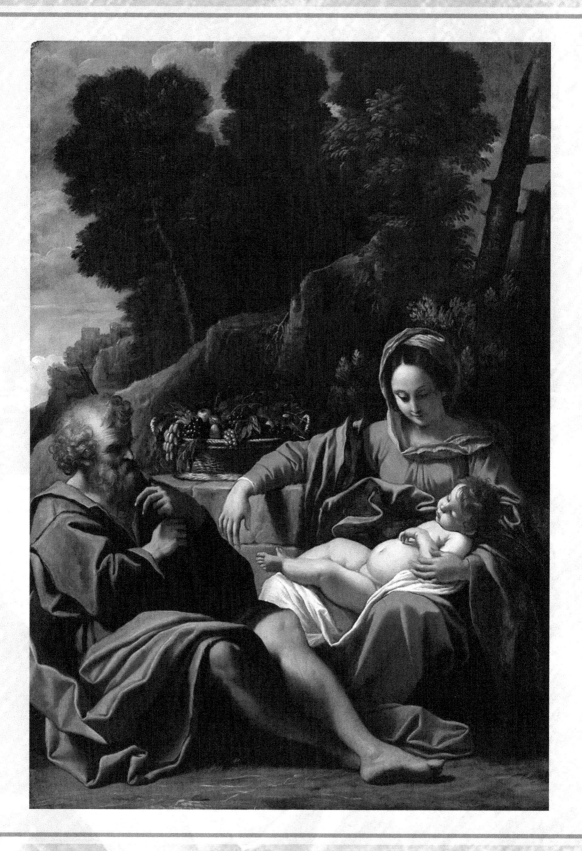

Hail, Holy Queen

Hail, Holy Queen, Mother of Mercy,
our life, our sweetness and our hope,
to thee do we cry, poor banished children of Eve;
to thee do we send up our sighs,
mourning and weeping in this vale of tears;
turn, then, most gracious Advocate,
thine eyes of mercy towards us,
and after this, our exile,
show unto us the blessed fruit of thy womb, Jesus.
O clement, O loving, O sweet virgin Mary!

Pray for us, O holy mother of God,
That we may be made worthy of the promises of Christ.

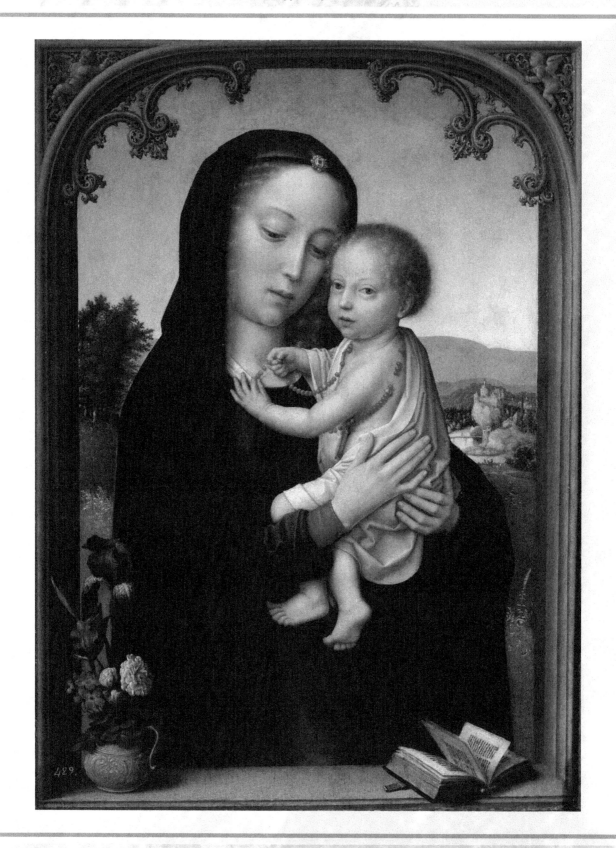

Concluding Prayer

O God, Whose Only-Begotten Son,
by His life, death and resurrection,
has purchased for us the rewards of eternal life:
grant, we beseech Thee,
that by meditating upon these mysteries of the
most holy Rosary of the Blessed Virgin Mary,
we may imitate what they contain,
and obtain what they promise,
through the same Christ our Lord.

Amen.

Artwork Index

The Visitation

The Birth of Our Lord Jesus Christ

The Presentation

HOW TO PRAY THE ROSARY

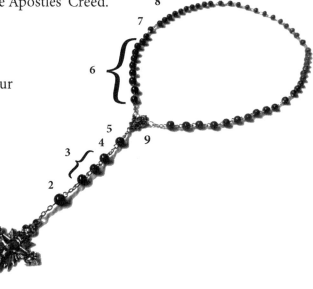

1. Make the Sign of the Cross and say the Apostles' Creed.
2. Pray an Our Father.
3. Pray three Hail Marys.
4. Pray a Glory Be.
5. Announce the mystery and pray an Our Father.
6. Pray ten Hail Marys.
7. Pray a Glory Be, followed by the Fatima Prayer.
8. Follow steps 5-7 for each mystery.
9. After completing five mysteries, pray the Hail, Holy Queen and the concluding prayer.

THE MYSTERIES OF THE HOLY ROSARY

The Joyful Mysteries

1. The Annunciation
2. The Visitation
3. The Birth of Our Lord Jesus Christ
4. The Presentation
5. The Finding of Christ in the Temple

Traditionally prayed on Mondays, Saturdays, and Sundays during the season of Advent.

The Sorrowful Mysteries

1. The Agony in the Garden
2. The Scourging at the Pillar
3. The Crowning of Thorns
4. The Carrying of the Cross
5. The Crucifixion and Death of Our Lord

Traditionally prayed on Tuesdays, Fridays, and Sundays during the season of Lent.

The Luminous Mysteries

1. The Baptism of Christ
2. The Wedding at Cana
3. The Proclamation of the Kingdom of God
4. The Transfiguration
5. The Institution of the Eucharist

Traditonally prayed on Thursdays.

The Glorious Mysteries

1. The Resurrection
2. The Ascension
3. The Descent of the Holy Spirit
4. The Assumption
5. The Coronation of Mary

Traditionally prayed on Wednesdays and Sundays.

SIGN OF THE CROSS

I believe in the Father and of the Son and of the Holy Spirit. Amen.

THE APOSTLES' CREED

I believe in God, the Father almighty, creator of heaven and earth, and in Jesus Christ, His only Son, our Lord, who was conceived by the Holy Spirit, born of the Virgin Mary, suffered under Pontius Pilate, was crucified, died, and was buried; He descended into hell; on the third day He rose again from the dead; He ascended into heaven, and is seated at the right hand of God the Father almighty; from there He will come to judge the living and the dead. I believe in the Holy Spirit, the holy catholic Church, the communion of saints, the forgiveness of sins, the resurrection of the body, and life everlasting. Amen.

OUR FATHER

Our Father, who art in heaven; hallowed be Thy name; Thy kingdom come; Thy will be done on earth as it is in heaven. Give us this day our daily bread; and forgive us our trespasses as we forgive those who trespass against us, and lead us not into temptation; but deliver us from evil. Amen.

HAIL MARY

Hail Mary, full of grace, the Lord is with thee; blessed are thou among women, and blessed is the fruit of thy womb, Jesus. Holy Mary, Mother of God, pray for us sinners, now and at the hour of our death. Amen.

GLORY BE

Glory be to the Father, and to the Son, and to the Holy Spirit. As it was in the beginning, is now and ever shall be, world without end. Amen.

FATIMA PRAYER

O my Jesus, forgive us our sins, save us from the fires of hell, lead all souls to Heaven, especially those in most need of Thy Mercy. Amen.

HAIL, HOLY QUEEN

Hail, Holy Queen, Mother of Mercy, our life, our sweetness and our hope, to thee do we cry, poor banished children of Eve; to thee do we send up our sighs, mourning and weeping in this vale of tears; turn, then, most gracious Advocate, thine eyes of mercy towards us, and after this, our exile, show unto us the blessed fruit of thy womb, Jesus. O clement, O loving, O sweet virgin Mary!

V. Pray for us, O holy mother of God,

R. That we may be made worthy of the promises of Christ.

CONCLUDING PRAYER

O God, Whose Only-Begotten Son, by His life, death and resurrection, has purchased for us the rewards of eternal life: grant, we beseech Thee, that by meditating upon these mysteries of the most holy Rosary of the Blessed Virgin Mary, we may imitate what they contain, and obtain what they promise, through the same Christ our Lord. Amen.

ABOUT THE AUTHOR

Karina Tabone is a wife, stay-at-home mother, writer, graphic designer, art aficionado, and recovering biochemical engineer who just happens to love Jesus. After trying various ways to nurture her young children in the Catholic faith while simultaneously sustaining an active prayer life for herself, she realized that examining religious artwork was a fantastic way of exploring the Catholic faith. Using the graphic design skills that she picked up while in the publishing and biotech industries, she designed Illustrated Rosary, a series that seeks to spread the practice and devotion of the Rosary through classic, religious art. In her spare time, Karina also runs Illustrated Prayer, a website that explores art, history, scripture, Catholicism, and prayer. She lives in Washington with her amazing husband and wonderful children.

Visit her website at www.illustratedprayer.com.

CPSIA information can be obtained
at www.ICGtesting.com
Printed in the USA
BVOW05*0754111117

499502BV00009B/14/P